Randolph Caldecott
His Books and Illustrations for Young Readers

Randolph Caldecott

His Books and Illustrations
for Young Readers

Robert J. Desmarais

June to September, 2006
Bruce Peel Special Collections Library
University of Alberta · Edmonton · Canada

Cover images: *Sing a Song for Sixpence*

Catalogue designed by Marvin Harder

Cloth
ISBN-10: 1-55195-209-2
ISBN-13: 978-1-55195-209-3

Paper
ISBN-10: 1-55195-207-6
ISBN-13: 978-1-55195-207-9

Published by University of Alberta Libraries
Copyright © University of Alberta Libraries
Edmonton, 2006

Preface

The books in this exhibition are from my personal collection, though I have borrowed a few duplicate copies from the Bruce Peel Special Collections Library to allow the covers and inside spreads of certain books to be displayed simultaneously. My hope is that this exhibition and catalogue will show that Caldecott was a pioneer in the way he beckoned his young readers with an innovative and engaging aesthetic approach to the picture book genre. Caldecott established a new standard of taste in children's picture books, and he achieved magnificent results. The stimulus to his imagination was evident throughout his oeuvre, which shows conclusively that he was born a master of observation. I invite you to explore this catalogue, and notice the way that Caldecott's work is filled with all the adventure and enchanting characters that an imaginative child could possibly desire.

Randolph Caldecott
1846–1886

Introduction

Randolph Caldecott had a special gift that enriched the lives of innumerable young readers in Victorian England and abroad. Although Caldecott is recognized for illustrating numerous magazines and books for adults, this is an attempt to show how his work represented a new kind of artistic vision of engaging young people with masterfully illustrated books.[1] Caldecott is perhaps best known for his sixteen *Picture Books*, published by George Routledge at the rate of two per year from 1878 to 1885, which were designed and printed by the famed colour printer, Edmund Evans. Caldecott's output as a children's book illustrator, however, extended beyond the much-celebrated *Picture Books*. In total, twenty-six titles make up the heart of his reputation as an illustrator who worked passionately to entertain young boys and girls. In looking at these books, readers see that Caldecott's legacy is both his originality of vision and his captivating style of pictorial narration.

Caldecott was born in Chester on 22 March 1846, six days after the birth of his fellow artist Kate Greenaway, and when he was fifteen he left Chester to work in a bank in Whitchurch, Shropshire. At the age of twenty, he went to work in Manchester as an esteemed employee of the prestigious Manchester and Salford Bank. This undoubtedly sounds like the life of an ambitious young executive, but Caldecott always had an artistic bent and he continued to sketch in the evening. Even while he worked at the bank during the day, Caldecott was known to make quick sketches on bits of note paper, old envelopes, and the blotting paper that rested on his desk (Blackburn, 9). One can imagine Caldecott taking short breaks throughout his busy day to draw the likeness of an unsuspecting customer or coworker. Outside the office, he took advantage of every opportunity to develop his skill by drawing people and events. Manchester was where Caldecott's life as an artist began on more industrious terms; here he studied as an evening student in the Manchester School of Art while also accepting commissions to make drawings for local magazines and newspapers.

Caldecott's first published illustration appeared in the *Illustrated London News* in November of 1861. He was commissioned as an illustrator-journalist to capture the terrible fire that destroyed the elegant Queen's Hotel in Chester. Henry Blackburn, the high-profile editor of *London Society*, was instrumental in accelerating Caldecott's artistic career by selecting many of his drawings for publication. The two men became close friends, and in 1872 Blackburn persuaded Caldecott to move to London to launch his career as an artist. London in the 1870s was a dynamic and inspiring place, and many aspiring artists settled here to launch their careers and market their work. Caldecott soon met the influential and well-connected artist Thomas Armstrong, and this friendship led to other introductions to accomplished artists, including George du Maurier, James McNeill Whistler, Albert Moore, and the French sculptor Jules Dalou. This active period of social and professional engagements was a momentous stage in Caldecott's artistic career, as he recalled in a letter to an anonymous Manchester friend on 21 July 1872.

> London is of course the proper place for a young man, for seeing the manners and customs of society, and for getting a living in some of the less frequented grooves of human labour, but for a residence give me a rural or marine retreat. I sigh for some "cool sequestered spot, the world forgetting, by the world forgot." (Blackburn, 32)

Caldecott eagerly heeded the call of London with its bustling streets and noisy crowds, but he always had an insatiable yearning for a quieter life in the country. This passion for pastoral scenes is reflected in many of his drawings. People are what interested him most, though, and he especially loved drawing ordinary folk in comical situations. Caldecott's work has the pleasing quality of congenial humour, particularly in his illustrations for children, and he always managed to infuse just the right amount of imaginative detail from the story or rhyme being illustrated, which remains the hallmark of the most impressive and enjoyable picture books.

Caldecott's work for children officially began in 1873 with a set of six illustrations that he drew for Captain Marryat's (1792–1848) *Frank Mildmay or The Naval Officer*, but he soon moved on to a very productive relationship with Edmund Evans to create the famous *Picture Books*. These books revealed a purposeful, creative mind at work, and they demonstrated that literature for children also belongs to and broadens the literary achievements of a country. Victorian England was not the sole beneficiary, however, of Caldecott's excellent work; on the contrary, young people all over the world inherited the magic of these special books. Caldecott provided an irresistible pictorial treatment of traditional folk tales, nursery rhymes, and contemporary stories that will forever enrich our literature for boys and girls. Caldecott's work set a high standard for the development of a genre, and his fresh ideas inspired generations of artists. Indeed, something musical is in Caldecott's work where every nuance of the story is made more meaningful by the vibrant rhythm between image and text. This sense of dynamic motion is Caldecott's vital contribution to enlivening the imagination of children. He never failed to animate the lines with pictures that are filled with energy, so that children can better appreciate the lively adventure within the stories. The *Picture Books* were so well received that Routledge soon reissued them in separate volumes of four, eight, and sixteen titles bound together. The British public adored Caldecott's *Picture Books*, and Evans contributed to their appeal with his ability to match Caldecott's colours so exactly with a wonderful matte finish, which enhances the beauty of the fine engraving. These books were a resounding success because nothing like them had ever before been offered, and they paved the way for the creation of numerous other children's books of lasting beauty and enchantment.

Without the expertise of Evans and his vision of what colour children's books could look like, Caldecott would have had difficulties expressing a new aesthetic standard for the picture book genre. The art critic Percy Muir made the astute point that Evans belonged to "the Apostolic succession from Bewick" in his fastidious commitment to continue developing Bewick's

elegant wood-engraving techniques (Muir, 157). Evans was meticulous in his selection and blending of pigments, and he took the time, risks, and initiative necessary to ensure that his letterpress printing process produced attractive results. In contemporary picture books, attractive colour is expected, but achieving this standard was considered a luxury in children's books from the Victorian period. The many publishers' commissions that Evans accepted to print brightly coloured covers for yellowback novels solidified his reputation, but he was eager to apply his talent to other challenging endeavours. By the time Evans started working with Caldecott, he had already produced a number of beautifully coloured toy books with Walter Crane, but the partnership ended when Crane grew disenchanted with what he considered to be inadequate remuneration from his publishers.

While working at Ebenezer Landells' workshop at St Bride's Court, London, Evans became friends with a fellow engraver, John Greenaway, father to Kate, and he soon became aware of her talent for drawing. In 1879 another significant partnership emerged when Evans applied his colour printing talents to Greenaway's *Under the Window*. What little is known about the way that Evans worked and how he achieved such magnificent results comes to us from his *Reminiscences*, and from the correspondence of illustrators who worked with him. Caldecott's letters to Evans reveal that their business relationship was fraught with disappointments and complications, and the colour that we see today in the *Picture Books*—reminiscent of the soft hues of watercolours—was actually the result of a painstaking effort by the two men to set a unique standard in picture book colouration. The delicacy and sophisticated application of colours that characterize Caldecott's illustrations are a testament to the determination of both men to distribute works of the highest quality despite the limitations of a tight budget.

The connection between Crane, Greenaway, and Caldecott is something quite extraordinary. They are forever linked by their common business partnerships with Edmund Evans—known collectively as "the triumvirate of Evans"—and their combined work represents the canon of beautifully designed

picture books from the Victorian era. These three artists contributed to a set of aesthetic standards for picture books, which are still evident in the work of modern artists. Their achievements, however, signified vastly different approaches to picture book design. Greenaway was an uncertain and impressionable artist, especially susceptible to the criticism and praise of the renowned art critic John Ruskin, and she respected his admonition to distance herself from all appearances of industrial ugliness and urban squalor. Instead, she sought to infuse art with the beauties of nature. When opening a copy of *Marigold Garden* (1885) or *Under the Window* (1879), readers immediately see that Greenaway filled her books, quite literally, with all the appeal and elegance of freshly blooming flowers. Her scenes are full of hope and happiness, with children forever playing games in breathtaking landscapes. Girls always appear in starched white sunbonnets and delicately coloured frocks, while the boys have freshly scrubbed faces and immaculately starched breeches. Greenaway was diligent in her efforts to purify her drawings, and in so doing she censored her picture books to eliminate anything unseemly. The trouble here is that Greenaway's picture books remain engrossed with an immaculate and unsullied childhood that few have ever experienced. Greenaway was resistant to giving children the opportunity to experience mischievous adventure—or any adventure for that matter—and she willfully held them back and never let them mature in authentic environments.

Caldecott understood the picture book on different terms. He knew that closing the eyes of children to the realities of life was disingenuous. His pictures convey a lasting impression of genuine childhood, and they confirm that life is filled with the unexpected. This is not to say that Caldecott freely included all the depravities of life in his work, he simply wanted to preserve all the realities that go hand-in-hand with our daily existence.

Walter Crane also stimulated the feelings of his readers, young and old alike, but one gets the sense of walking through a particularly impressive museum exhibit. While his pictures of ornate and richly decorated rooms evoke the feeling of looking at a grandiose painting, his work also seems to carry a hushed

subtext of "look but don't touch". Crane's primary concern was that of a fastidious decorator, and he would have done a brilliant job designing the interiors of the world's finest museums. Most children, however, are not content in stuffy museum-like environments where they are expected to be quiet while an adult takes them on a guided tour. In a similar vein, Crane's toy books have a formality about them that seems to direct children from picture to picture in the tradition of a prescribed museum tour.

Caldecott constructed his *Picture Books* to operate not as guided tours, but as adventures experienced from the child's perspective. He understood that narrative perspective presents an opportunity for the picture-book artist to show *and* tell from the position of a curious child-narrator. Caldecott's storytelling impulse was to illustrate young characters who address the child directly. The adult characters, on the other hand, address each other, and Caldecott pictured them in iconographic moments that are memorable and easily recognizable. Ingeniously, he accomplished a dual narrative voice: one for adults and the other for children. Caldecott knew that in order to relate to the child, he needed to create characters that reflect a youthful curiosity. In scene after scene, Caldecott included a child who peers directly at the reader, reminding girls and boys that they, too, are included in the unfolding story.

The wonders of Caldecott's illustrations are plentiful. Caldecott knew that children are small, valiant people who yearn for adventure, and he never failed to give it to them. Some scenes are entirely fantastical and feature talking animals, while others are more playful, with images of children playing war games or climbing trees. In scene after scene, Caldecott persisted in giving delight by showing a bevy of characters engaged with exciting activity. The child has a tendency to enjoy this spectacular world in terms of lively events, of memorable characters, of imaginative adventures. Of course, Caldecott knew that there is no rule that an illustrated book must be about everyday occurrences for children to be able to identify with it; instead, he presented an enormous range of magical and nonsensical exploits to engage his audience.

Among the foremost conditions that Caldecott firmly established in his work, we find character complexity and growth. Characters are not understood from the text alone; rather, Caldecott presented the complexity and dynamism of characters in different settings, where dull characters were rejected for the other extreme. Caldecott's illustrations are a momentous transition from the old pedantic children's fiction, with its pictures of static, undeveloped characters. By contrast, Caldecott's characters possess familiar traits, both positive and negative, and children get to know them and love them as the story progresses. What boy or girl is not in awe of the boy-King and girl-Queen in Caldecott's *Sing a Song for Sixpence* (1880) as they are seen enjoying the many luxuries and pleasures of a royal household? These child characters are shown to be naïve and indulgent, but they are also gentle and loving. In the final scene, Caldecott showed the happy royal couple arm-in-arm enjoying a stroll through their sumptuous garden. Their various traits are revealed in different ways—including contrast, repetition, and facial expressions—but perhaps most significant is the way that characters are allowed to mature on multiple levels within the framework of their journeys and adventures. The difference between character development in previous children's fiction and Caldecott's work is his candid depiction of character evolution. Everything we learn about Caldecott's characters is revealed through their illustrated actions as well as the visual presentation of their emotions. The *Picture Books* show conclusively that Caldecott was not willing to subordinate character to action.

The *Picture Books* are certainly fundamental to Caldecott's work for young people, but he was also commissioned by several children's authors to illuminate their stories. Caldecott always made sure to give young people the very best pictures to look at, and he was meticulous in portraying characters with all the complex nuances of mood appropriate to the dramatic circumstances. What a wonderful and unforgettable introduction his drawings are to the astonishing range of human emotions. In this respect, young readers had unprecedented opportunities to experience the pleasure of anticipation and

the pain of misfortune at some heartbreaking moment in the story. What child could forget seeing the illustration that Caldecott provided for Juliana Ewing's *Lob Lie-by-the-Fire, or The Luck of Lingborough* (1885) when Miss Betty screamed upon discovering an abandoned baby sleeping on a pillow of damp moss? Readers are immediately piqued by the unexpected picture of a lone child sleeping in the folds of a dirty cloth. Caldecott offered no apologies for communicating a full range of emotions, and his illustrations show that children needed this exposure to develop their imagination and to learn about reality. But Caldecott also did his best to represent the world of magic and fantasy. The extraordinary things that happen to young Jack in Hallam Tennyson's *Jack and the Bean-Stalk* (1886) are wonderfully illustrated, and there is continual play upon the child's notions of his or her own identity in the world as the young reader follows Jack as he climbs the mysterious beanstalk. Jack's efforts to evade the villainous giant are just the sort of adventure that a young reader would pore over with great enjoyment, and Caldecott provided just the right counterpoise to the horror of being chased down a winding vine with his comical picture of the fat giant's corpse at the story's conclusion. We come to understand that Caldecott had a sense of humour and wanted to remind his young readers of its power and presence in what may appear to be the direst of circumstances.

Caldecott intended to please children, and his break with tradition came in the way he approached them and offered an invitation to participate in the story as children. His illustrations are commonly depicted from the child's point of view, and he provided a place that children could call their own by supplementing his illustrations with enough humour and adventure to enchant every young reader. Caldecott illustrated from the principle that one should have a view from the inside of the child's mind, to re-create what it felt like to experience a full range of everyday occurrences and exciting adventures. He never assumed that children were oblivious to pain and suffering and thus saw the world without awareness of the callousness and sorrow within it, as we see in Caldecott's

sensitive portrayal of abandoned children in *The Babes in the Wood* (1879). He included a full range of human experience because he understood that much growth and struggle were still on the horizon for young people. Caldecott's illustrations played an important role in a child's growth; the details that define his pictures imply that children are able to deal with the freedom of living in all kinds of worlds, regardless of whether they are idyllic, fantastical, nonsensical or perilous. All of these worlds are depicted in Caldecott's work to fulfill young readers' yearning for self-exploration, and he was clearly inspired by the notion that children desire the risk and excitement of burgeoning adventure.

What makes Caldecott's *Picture Books* so appealing is the sense that he made them both for children and for adults; he never discriminated against one or the other. In fact, Caldecott managed to produce an extremely sensitive portrayal of some of the most unimaginative everyday activities—walking down a street, getting a haircut, riding a horse—because he invested vivid emotion in the visual narrative that can be discovered throughout the book. He understood the pleasure of sensuous experience, and on close examination, as in *The Diverting History of John Gilpin* (1878), the touch and smell of riding a horse—an otherwise ordinary event in Victorian England—suddenly becomes very intimate and real. Caldecott's intention was to preserve all the robust liveliness that goes hand-in-hand with our daily existence. His illustrations suggest that he was particularly interested in giving children the opportunity for mischievous adventure, and sometimes stirring poignant feelings that are necessary for reflection, growth, and individuation.

Fortunately, Caldecott never used his drawings to pressure children to learn moral lessons or other forms of social pedantry. Caldecott did quite the opposite with his illustrations of young people, showing that children have distinct talents and personalities, and that they are fully capable of making their way in the world without strict rules and adult supervision. Numerous scenes offer compelling evidence that Caldecott's supreme desire was to stimulate the young reader's imagination with the sense that children have unlimited potential.

The art of Caldecott's *Picture Books* brings one into the company of lively characters, whose personalities and actions provide plenty of scope for the imagination. Caldecott also soon recognized an opportunity to place animals and ordinary household objects in a new symbolic system where their visual appearance and behaviour encourage the viewer to construct an imaginary, human existence for them. He achieved something unique by persuading young readers to identify with the non-human characters in his books. They become heroes to children because Caldecott drew them pursuing adventures in an altogether new and unexplored world, and he equipped them to respond to that world with a variety of human emotions, passions, and capabilities. In following the curious exploits of these lively characters, the child is given a sense of intellectual and emotional expansion beyond his or her limited social setting. Children come to appreciate a certain pleasure in finding mirrors of themselves in these magical characters—a frog that dances, cats that sing, festive rats—and soon realize that the various characters are actually projections of their own traits and emotions. Knowing that pictures of grown-up people were not always the best way to get children to immerse themselves in imaginative events, Caldecott chose to develop the personalities of animals and household objects. Their characteristics are rendered in human terms, and are seen to inhabit a world scaled to the perception of an inquisitive child.

The recurring picture of the animal that thinks and talks for itself is a powerful icon in Caldecott's campaign to captivate children. In a well-known scene from *The Queen of Hearts* (1881), in which the Knave of Hearts is caught stealing the legendary tarts, we see that Caldecott personified an ordinary cat by giving it a point of view and allowing it to become involved in the plan to capture the thief. On another page the cat is shown in an animated state, explaining to the King that the Knave is responsible for pilfering the tarts. Caldecott regularly drew animals that had their own personalities. From an early age he was sculpting animals from wood and clay, and he looked to ordinary barnyard animals for inspiration. When Caldecott drew animals with their own personalities, he

socialized the young reader to a picture-book world where bold attempts were made to reflect the child's perspective and imagination. Had his stories been told purely from an adult perspective—without animals that sing, talk or dance—the *Picture Books* would have less meaning for children because they would have no easy way to step into and enjoy the narrative. Caldecott wanted his animals to function as ambassadors, inviting children into the story without evoking the feeling that they were under adult supervision.

With the publication of *Hey Diddle Diddle* (1882), the British public witnessed a fresh treatment of the exciting antics that unfold when the infamous dish runs away with the spoon. In one memorable scene, Caldecott has all manner of chinaware singing and dancing in celebration of the dish-spoon elopement. While the matrimonial theme in this picture has obvious significance to many adult readers, Caldecott was also hoping to appeal to little children through their eyes. The book is filled with humorous characters that are distinctive and pleasure-giving—dancing water jugs, animated wine decanters, angry knives—and all of these lively characters, with their festive clothes and eccentric behaviours, are designed to appeal to the child's mind and emotion. When Caldecott drew his characters he was very conscious of how they would be perceived through the eyes of a child, and this is why he designed settings and circumstances for his characters that have meaning for children. For example, the final scene of *Hey Diddle Diddle* shows the spoon being escorted away by her angry parents, the knife-father and fork-mother, and the sobbing plates are seen gathered around their friend, the serving dish, who lies in pieces on the ground. The scene has a special relevance to all children who have ever been scolded by their parents for misbehaving, while children will also relate to the tragedy of seeing a friend in trouble. In looking at Caldecott's work for young people, one is reminded that there are two principal aspects to illustrating children's books: the lighthearted and the serious aesthetic. Caldecott never separated the two; his purpose was to make a book as pleasurable and as beautiful as possible. Moreover, his illustrations provided children with the pleasure of forgetting

about their worldly cares and responsibilities. Caldecott wanted children to experience the emotions, thoughts, and actions of a full variety of fascinating characters. This process of making literature meaningful to children by offering intricate patterns of emotional involvement was unprecedented. Caldecott managed to add to the potential of children's literature, enrich the entire genre, and forever delight his readers with stimulating adventures. While he led a short life, claimed in the end by tuberculosis, Caldecott established a radically new method of producing illustrated books for children. His work inspires us to remember him with appreciation for creating a way for all readers to truly immerse themselves in the story. This exhibition catalogue is meant to display and confirm Caldecott's innovative method of visual narrative, along with his wonderfully distinctive iconography.

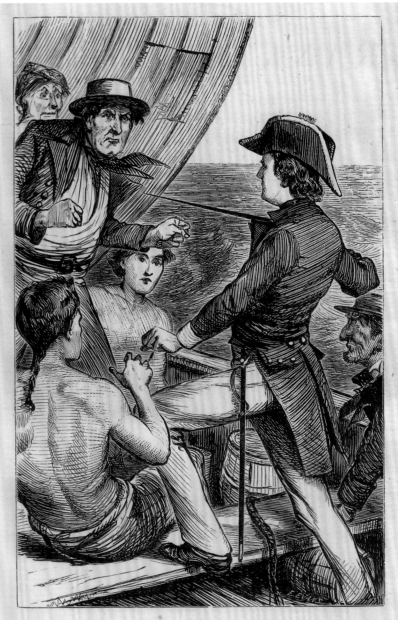

"I drew my sword, and pointing it at the breast of the nearest mutineer, desired him, on pain of instant death, to return to his seat."

figure 1

1. Frank Mildmay or The Naval Officer

Captain Frederick Marryat
London: George Routledge & Sons, 1873

Caldecott was commissioned to provide six black-and-white illustrations for Captain Marryat's book about exciting sea voyages (originally published by Henry Colburn in 1829), and they each do a remarkable job of capturing just the sort of swashbuckling adventure on the high seas that the curious and imaginative young reader would have found engrossing. The first illustration is opposite the title page, and Caldecott clearly wanted to convey a dramatic sense of adventure, which is evident in the way that Mildmay brandishes his cutlass and points it threateningly at the chest of a mutineer (fig. 1). This scene reminds us that Caldecott had a keen eye for depicting suspense. He continually persuaded young readers to identify with daring heroes, but perhaps more interesting, he knew how to make readers feel like they wanted to be "in the book". Caldecott must have known that his treatment of suspense had struck a chord with his audience, because his later titles show that he was eager to develop further ideas on the depiction of fast-paced dramatic action, so the reader is bound by overwhelming curiosity to turn the page briskly to see what happens next. Indeed, when we examine the final illustration in *Frank Mildmay*—where fretful young Emily discovers the result of an apparent suicide attempt—we see that Caldecott was quite adept at urging viewers to respond empathetically to startling visual cues, emboldening the reader to guess at what scenes might unfold on the following pages.

These early drawings show that Caldecott was sympathetic to England's literary appetite for romance and imperial adventures. But while these pictures demonstrate his sensitivity to the prevailing mood in young boys' fiction that proclaimed romance's appeal over realism, he soon had the opportunity to exercise complete control in his *Picture Books*.

2. Baron Bruno or The Unbelieving Philosopher and Other Fairy Stories
Louisa Morgan
London: Macmillan & Co., 1875

Macmillan published *Baron Bruno* with deep blue cloth covers and an eerily designed title was stamped in gold and black (fig. 2). The simple design of an arched window on the front cover frames a pretty constellation of gold stars; it imitates the dreamy feeling that many children experienced while gazing through a bedroom window on a starry evening. Caldecott provided eight black-and-white illustrations for Louisa Morgan's stories, a collection that reminds readers of the Grimms' fairy tales, but while the drawings are quite beautiful, they have little in common with his later work for children. Rather, they resemble the ornate and overly decorated style of Walter Crane's work. Caldecott had just begun to illustrate books, and he had yet to develop a distinctive style. What we see in *Baron Bruno* is not representative of Caldecott's most often quoted comments on drawing: "The art of leaving out as a science...the fewer the lines, the less error committed" (Blackburn, 126). Despite this disparity, we still have a lot to appreciate and admire. The illustration of Eothwald and Duva in the cave is particularly enchanting, and young readers were certainly pleased with Caldecott's fine lines that capture the beauty of the two mermaids so remarkably. Victorian children would have seen, perhaps for the first time, the extraordinary beauty of an archetypal mermaid with her long flowing hair, gentle curves, and supernatural tail. The intricate pattern of interlocking scales on the mermaids' lower bodies encourages readers to look closely, and the fine detail of the cave's ceiling creates an ominous and foreboding mood (fig. 3). These exquisite lines, of course, are the work of a meticulous decorator, but Caldecott was much more than a decorator. His work for children developed along a less formal artistic path, as we will see in the innovative pictorial narrative techniques in his *Picture Books*, and he also sharpened his focus on methods to captivate children with energized pictures. The

figure 2

illustrations in *Baron Bruno* are certainly alluring, but they are not linked together in a seamless pictorial narrative with the strong sense of motion that Caldecott developed and perfected in the *Picture Books*.

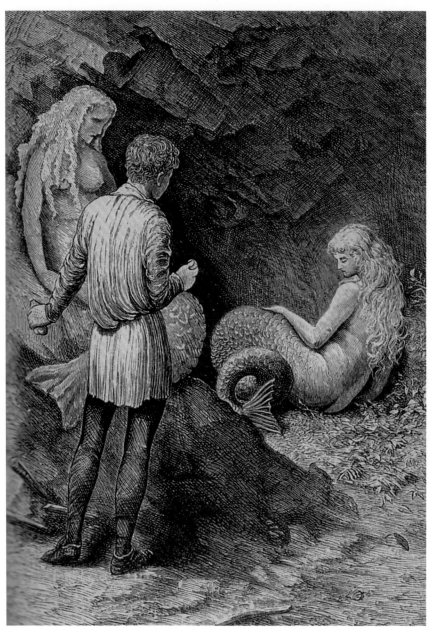

figure 3

figure 4

3. The House that Jack Built
Randolph Caldecott
London: George Routledge & Sons, 1878

This first title in the famous *Picture Books* series originally
appeared in print in 1766, and also appeared as a *New Shilling*
series book by Walter Crane in 1865. Edmund Evans initially
printed 10,000 copies of this title and *The Diverting History of
John Gilpin* (published in the same year), but the overwhelm-
ingly positive reception of the series later required much larger
print runs. Evans wrote in his *Reminiscences* that, "The sale of the
Toy Books increased so that I printed 100,000 first edition" (59).
On a contradictory note, Elizabeth Billington wrote in her
Randolph Caldecott Treasury that Caldecott's younger brother
Alfred compiled his own sales figures, which were dissimilar to
those of Evans (65). Curiously, the archives of George Routledge
& Company (1853–1902) contain no corroborating evidence
on the exact print runs of the *Picture Books*; unfortunately,
the records are incomplete and thus offer no insight into the
various figures. *John Gilpin* is known to have been the most
popular book in the series, however, and Billington cited a sales
figure of 112,000 after ten years, with other titles selling at a rate
between 6,000 and 7,000 copies annually.[2] All of the *Picture
Books* sold for one shilling each, making them quite appealing
with their competitive price and high quality.

 Before Routledge published *The House that Jack Built*, the
British public had never seen such well-designed picture books.
The buoyant words of the reviewer from *Punch* on 14 December
1878 signaled the beginning of a new picture book tradition:
"the book for children" (4). *The Times* was equally impressed in
its review on 24 December: "the very essence of all illustration
for children's books" (9). Up until this point, readers were
accustomed to seeing picture books that were little more than
cheaply made chapbooks with dull illustrations. Caldecott
freed his illustrations from the thick black borders that added
to the ugliness of previous children's books. *The House that
Jack Built* not only represented a new aesthetic style, it also
stimulated readers with a vastly improved pairing of words and

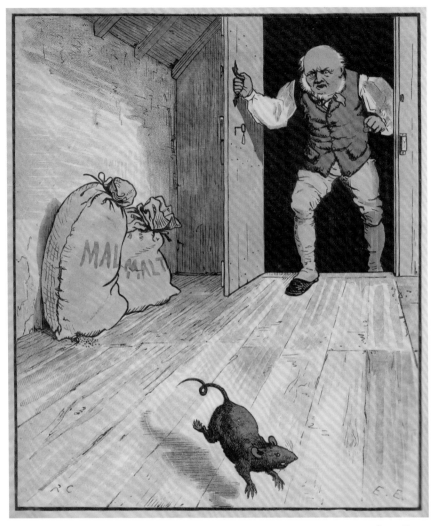

figure 5

pictures. Caldecott wanted his readers to take pleasure in these rhythmic effects. For example, the opening spread of *The House that Jack Built* shows a beautiful three-storey home with immaculate lawns and shrubbery, and a finely dressed man extending his hand toward his property in a gesture of great pride. The few words of text on the spread typify the seamless integration between words and pictures: "This is the House that Jack built". When the words are read, readers expect to see a beautiful home worthy of this proud declaration, and Caldecott has given it to them. The initials EE in the bottom corner of the illustration are a common feature of the coloured illustrations, showing that Evans personally engraved the wood blocks. His fine craftsmanship and fastidious applying of inks ensured a rich sensory impression that was unprecedented.

This title can hardly be regarded as simply the first of a series. Rather, it is the beginning of a new pictorial framework, for what Caldecott brought to the picture book tradition was an affective impression of the English countryside. Caldecott also showed a remarkable level of sophistication in the way that human qualities are communicated visually. Characters in this book are empowered in all variety of manners because they are placed in situations where readers want and expect them to have thoughts, emotions, and lively body language. For example, when Caldecott drew a scene of poor old Jack opening the door to his attic to discover a rat eating his bags of malt (fig. 5), readers likely anticipated that this character should feel shocked and angry. Readers sensed Jack's anger by looking at his furious expression and clenched fist. What made Caldecott such a master in the art of visual characterization was his ability to create dichotomies that encouraged readers to root for one character over another. A fine example of this is the rat that appears in the immediate foreground looking equivalent in size to Jack's entire upper body, giving the impression of a formidable foe. Caldecott froze the rat in midair, with malt wedged in its mouth, and the entire scene gives the overwhelming impression that the rodent is guilty and deserves retribution. Clearly, Caldecott empowered his characters by showing how they react to the world around them.

4. The Diverting History of John Gilpin
Randolph Caldecott
London: George Routledge & Sons, 1878

This William Cowper (1731–1800) story had a much longer title
when it was first published in 1785: *The Diverting History of
John Gilpin: Shewing How He Went Farther Than He Intended, and
Came Back Safe Home Again*. Edmund Evans was so impressed
with the immensely popular work that Caldecott had done on
Washington Irving's *Old Christmas* (1875), with its 120 black-
and-white illustrations, that he arranged a meeting to propose
creation of a new toy book series. Evans wrote about that historic
meeting in his *Reminiscences*, and his words reveal how commit-
ted both men were to a new aesthetic standard for picture books.

> He liked the idea of doing them as I proposed, and fell in
> with me very pleasantly, but he would not agree to doing
> them for any fixed sum: feeling sure of his own powers in
> doing them, he wished to share in the speculation—said
> he would make the drawings—if they sold and paid, he
> would be paid, but was content to bear the loss if they did
> not sell, and not be paid: so I agreed to run all the risk of
> engraving the key blocks which he drew on wood: after
> he had coloured a proof I would furnish him, on drawing
> paper, I would engrave the blocks to be printed in as few
> colours as necessary. This was settled, the key block in *dark
> brown*, then a *flesh tint* for the faces, hands, and wherever
> it would bring the other colours as nearly as possible to
> his painted copy, a *red*, a *blue*, a *yellow*, and a *grey*. (I was
> to supply paper, and print 10,000 copies, which George
> Routledge & Sons have published for me.) I asked him to
> come and see me at my house at Witley, which he did, and
> we talked over the subjects of the two first books. We agreed
> to publish together, in the Autumn of 1878, *The House that
> Jack Built* and *John Gilpin*. Shilling Toy Books, at that time,
> generally had blank pages at the back of the pictures: I pro-
> posed to have no blanks at all in these books: these slight
> illustrations were little more than outlines, but they were so

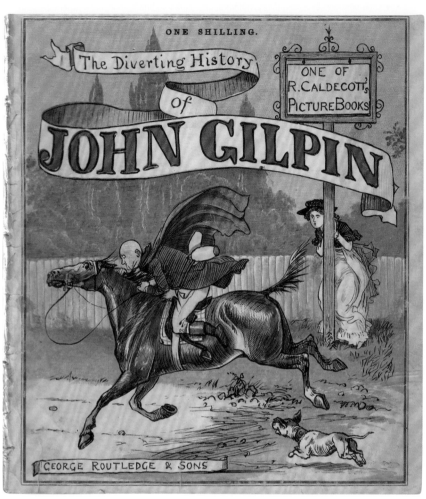

figure 6

racy and spontaneous. R.C. generally drew them from his friend where a man was wanted: his cats, dogs, cows, showed how thoroughly he understood the anatomy of them. If the sketches came all right, he let them pass—if he was not satisfied with the result, he generally tore them up and burned them. They were made in pen and ink on smooth-faced writing paper, post 8vo size, photographed on wood, and carefully engraved in 'facsimile'—Process work was not sufficiently perfected at this time to reproduce the drawings by this method. (Evans, 56)

The publication of *John Gilpin* was an impressive feat, and the public was immediately attracted to the fresh colours and Caldecott's irresistibly entertaining illustrations. Evans applied his inks with special care, and the distinctive achievement of this book is that its colours are never uneven or blotchy. This book also shows how Caldecott liked to pique his reader's curiosity to turn the page, and the ghostly woman hiding behind a pole on the front cover is a fine example of this technique (fig. 6). Readers were likely asking themselves why this woman was staring so intently at a bald man on a racing horse. The bewildering scene stirs the imagination with a barrage of questions, which is typical of Caldecott's meticulous efforts to create the sense of an unfolding drama. When readers leaf through this they are immediately struck by the ebb and flow of continual motion: women are shopping, carriages roll down the streets, John Gilpin gallops at breakneck speed, children scream, dogs bark, the townspeople engage in a highway pursuit, and Gilpin is mistaken for a thief. Young readers were surely captivated by the dynamic action and the sense of wanting to know what happens next. *John Gilpin* offered readers a chance to cheer on an unlikely hero who simply wanted to arrive on time for his twentieth wedding anniversary in Edmonton. The most charming feature is not so much the comedy of errors evident in the text, but rather the way that the illustrations hold out the promise of a helter-skelter adventure.

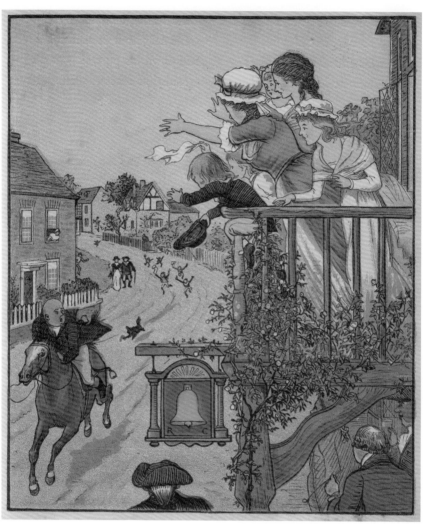

figure 7

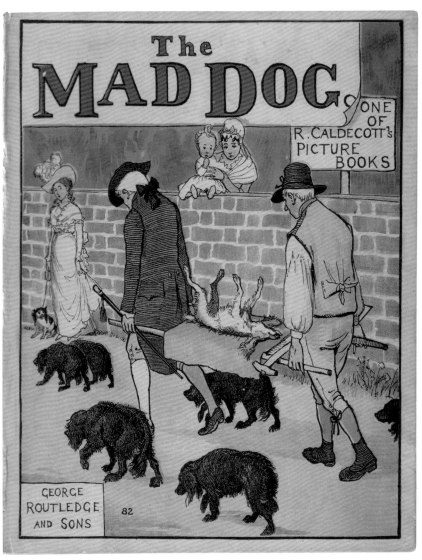

The
MAD DOG

ONE OF R. CALDECOTT'S PICTURE BOOKS

GEORGE ROUTLEDGE AND SONS

82

figure 8

5. An Elegy on the Death of a Mad Dog
Randolph Caldecott
London: George Routledge & Sons, 1879

Mad Dog is an Oliver Goldsmith story, rich in humour and entertainment, and Caldecott introduced a pictorial dimension that truly delights. The front cover illustration with the procession of black-coated dogs, heads hanging low, is the kind of comedy that was certainly appreciated by readers of all ages (fig. 8). The funeral procession is made to look all the more ridiculous by the deceased dog having its legs outstretched in an exaggerated state of rigor mortis. Evans printed the covers on green paper, which accentuates the mood of bereavement and, strangely enough, seems to add further nuance to the gentle satire. Caldecott understood how to stir the emotions of his audience with drawings of people and animals in bizarre situations. This story afforded Caldecott many opportunities to add hilarity to what would otherwise be a simple tale of a kind man who befriends a homeless dog and adopts it as his own. On a purely narrative level, the twist at the end is equally mundane with the dog biting the man's leg (fig. 9) because of his new interest in the household cat. The dog becomes jealous and serves out its revenge in a playful bite. These circumstances are hardly the makings of great comic material, but Caldecott adds magic to the tale in his renderings of the mayhem that results from the attack. In one frantic scene the dog is pictured leaping down the street and scaring away all of the townsfolk. One frightened man is seen climbing a tree to escape the danger while others run into shops and over walls. The woman who protects herself with an open umbrella is especially amusing.

Whether Caldecott's young readers were cheering for the mad dog or the cowardly townspeople is a moot point; the delight of this book is its sense of energy and motion. Readers were surely engrossed by the scene depicting a mass exodus of the terrified townsfolk (fig. 10). Caldecott often used several full-page illustrations, one after the other, to depict a brief moment in time, thus giving the impression of watching an important scene in a motion picture. Of course, his Victorian

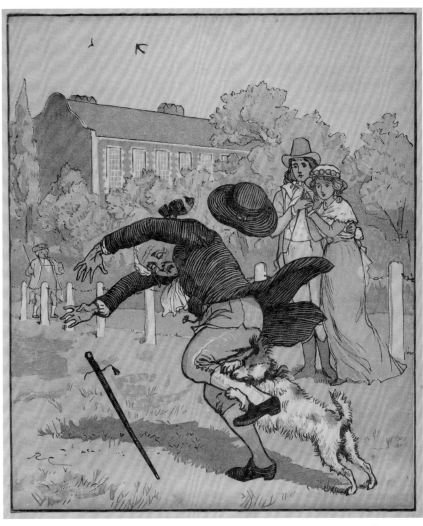

figure 9

readers had no experience of film, but they would have appreciated the sense of drama, rhythm, and music from their experience of theatre. This picture book does not mean as much to adults as it does to young boys and girls who are better able to appreciate the trifling adventure of a pitiable dog. They would also be pleased about the full-page illustration showing a catalogue-like presentation of the different kinds of dogs in the town, making it easy for young readers to identify and name the various breeds. The beauty of the book is seeing how Caldecott drew the many dogs that make cameo appearances (fig. 11); he later developed a reputation for having more affection for dogs than for cats.

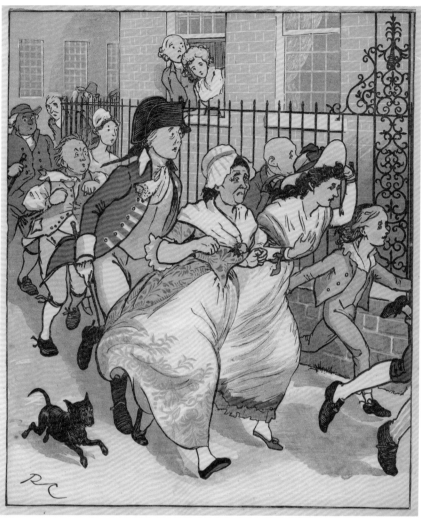

figure 10

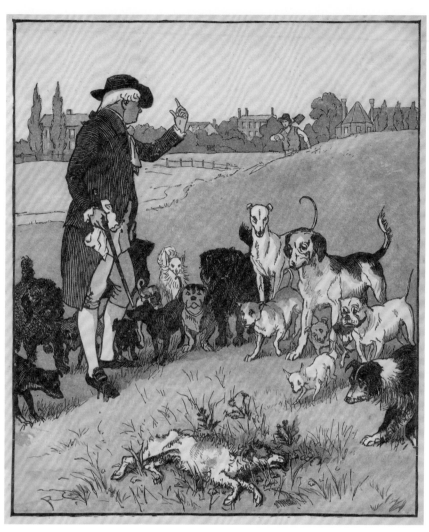

figure 11

6. The Babes in the Wood
Randolph Caldecott
London: George Routledge & Sons, 1879

Caldecott drew the illustrations for this book during a grueling period of ill health, and one cannot help but wonder if his mood magnified the rather ominous tone of this sad tale.[3] The heart-wrenching story, featuring two young children who are left to die in the forest, is made all the more chilling by the escalating sense of panic and terror that is captured in the expressive faces of the children. By far the most unusual scene is depicted on the final page where readers see the dead children wrapped in each other's frail arms under a pile of leaves (fig. 12). This book is all the more valuable to collectors because of its morbid narrative and grim illustrations, which are so completely out of step with Caldecott's other works. Caldecott never explained why he chose to illustrate such a dark tale out of the hundreds of nursery rhymes that were available to him, but it seems that he became intrigued with death and felt that this element of the life cycle was a worthy addition to his *Picture Books*.

Undoubtedly, the image of the terrified children on the front cover (fig. 13) was sufficiently morbid to tip off most reviewers that Caldecott was willing to take significant risks with children's picture books. One must remember that Caldecott began his career working as an illustrator-journalist for the *Illustrated London News*, and he was quite accustomed to seeing, and then illustrating, human tragedy. The look of terror on the children's faces would have been a common sight for any journalist covering the local news. Adding to the unusual qualities of the book is the peculiar choice of green paper for the front and back covers. Evans may have thought this an appropriate choice to complement the black sky, and one could certainly argue that it adds to the ghoulish feeling of being lost in a strange forest. One can only imagine whether Victorian parents, after gazing upon the sinister colours, thought this book appropriate for their young children. Evans did not seem to have any doubts about its appeal, however, and he was likely responsible for suggesting Caldecott take a risk and illustrate the old rhyme. Evans

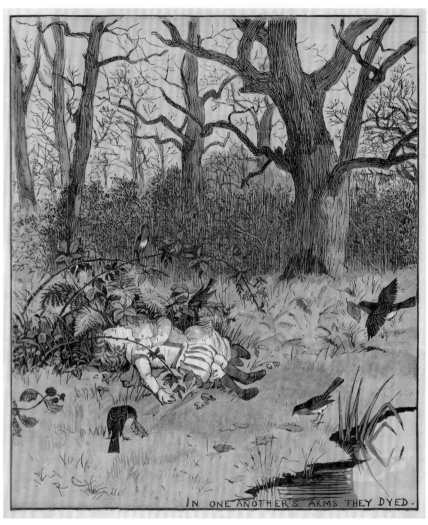

figure 12

23

had previously issued *The Babes in the Wood* as one of Aunt Mavor's *Everlasting Toy Books* (1860), and he was perhaps curious to see if Caldecott had the ambition and vision to breathe new life into the tale. Caldecott took up the challenge with a sense of humour by using Evans as the model for one of the "ruffians strong" who lead the children into the forest to their sad demise (Billington, 38). It also seems likely that Caldecott cast himself in the role of the children's father who was "sore sicke...and like to dye" (fig. 14). Indeed, the physical similarities between the two are striking—including the handsome face, gentle eyes, high forehead, and light brown hair— but we will never know if Caldecott also felt any affinity with the father's sense of helplessness and foreboding doom. What we do know is that Caldecott felt a sense of confidence in expressing himself in his illustrations regardless of whether the source of his artistic inspiration was sad or joyful.

Caldecott showed the world that children have all the feelings, thoughts, and manners of grown-up people, and he dispelled the Greenaway notion that all children live in unblemished worlds where their happiness is assumed. Here, Caldecott told the story of two young children who are left in the trust of a duplicitous uncle after the untimely death of their parents. The uncle quickly tires of supporting the children and he employs two "ruffians strong" to murder the unsuspecting children while on a walk in the forest. This dark tale was not typical of the happier themes in the *Picture Books* series, but Caldecott accomplished something entirely original by depicting children immersed in a complex web of human relationships. In effect, Caldecott socialized young readers and prepared them to handle the darkest of human relations. Whereas Greenaway encouraged children to never relinquish their innocence and emotional dependency on adults, Caldecott created resolute child characters that acted independently (fig. 15). Furthermore, Caldecott filled his *Picture Books* with children who were not necessarily the paragons of dutiful submissiveness that Victorian culture so cherished.

Caldecott raised the capacities of children by showing that they could be out and about in the world, learning to make the

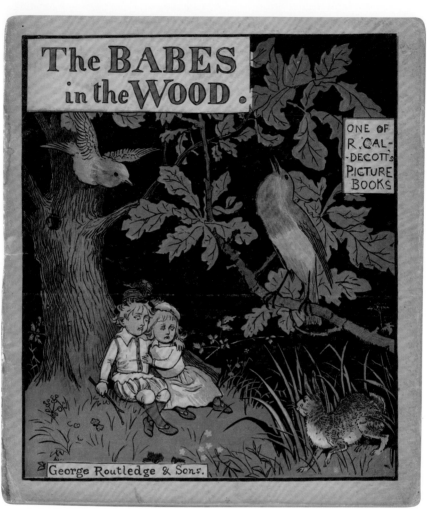

figure 13

best of necessity by coping with evil influences, follies, and vice. In a later scene, the children watch a grisly murder (fig. 16), and Caldecott ingeniously showed that children gain strength from each other. Caldecott was careful, however, not to illustrate stereotypes where characters are shown to possess only one feature amplified almost to caricature. The children in this book are certainly frightened, but they also brave the perils of the forest. Caldecott, in that sense, created well-rounded characters that encouraged Victorian readers to "care" for them, which suggests that the *Picture Books* were designed to evoke an emotional reaction. This emotional way of looking at characters, the adoption of an empathetic gaze, defined the way that Caldecott expected his readers to view his narrative pictures.

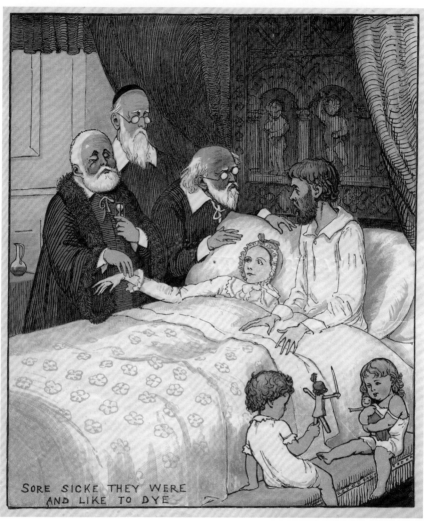

figure 14

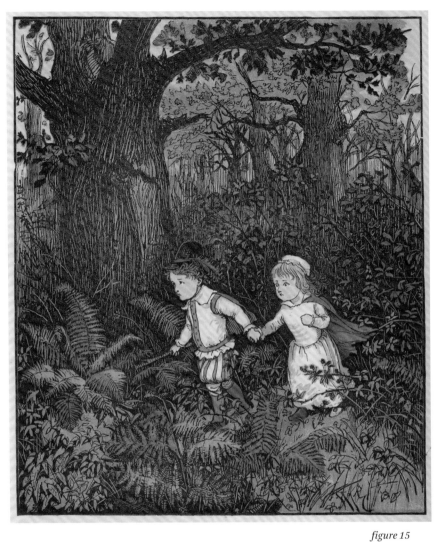

figure 15

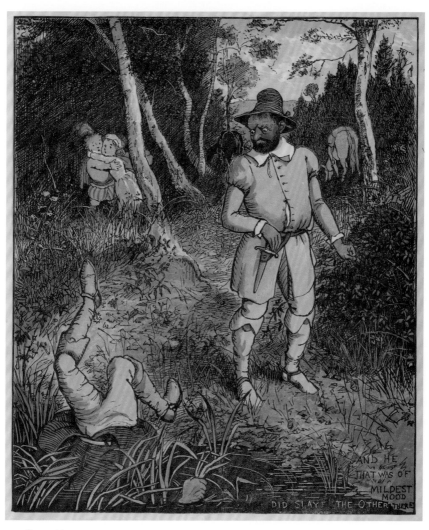

figure 16

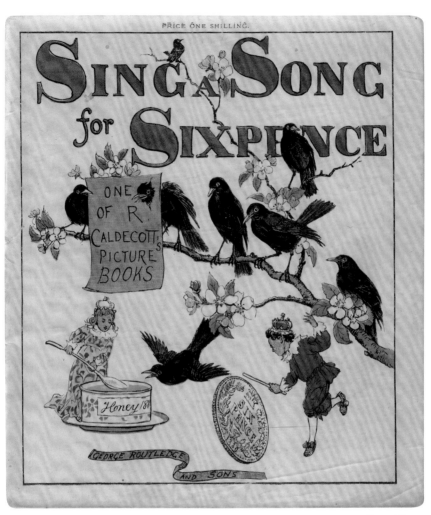

figure 17

7. Sing a Song for Sixpence
Randolph Caldecott
London: George Routledge & Sons, 1880

This classic rhyme can be traced back to the Elizabethan age, but Caldecott added his own touches to ensure that children would be completely enthralled by the simple story. He pictured the King and Queen of the tale as children, creating added interest for young readers who were unaccustomed to stories being told from their point of view. Caldecott also changed a single word in the title from the original nursery rhyme ("for" replaces "of"), and this is the first clue that he chose to illustrate a story far different from the original. The change suggests that the story is about singing for one's daily bread, or working for a living. Charles H. Bennett illustrated an earlier version of the rhyme in *The Old Nurse's Book of Rhymes, Jingles and Ditties* (1858), but there the King is portrayed as a short and portly old man who winces sourly when the "four and twenty blackbirds" escape from his pie. In stark contrast to Bennett's dour King is Caldecott's boy-King who looks upon his bird-filled pie with great amusement (fig. 18). He is also an enterprising young man who enjoys counting his money (fig. 19). The girl-Queen is also depicted as the kind of child who wants nothing less than to enjoy her childhood by having tea parties and playing games. Victorian girls probably looked with envy at the scene where Caldecott has the young Queen eating honey and bread in a room filled with gorgeous dolls (fig. 20). After seeing the picture, many middle-class children probably asked their parents for the variety of wonderful toys that Caldecott put on display so liberally. The Queen's parlor is the kind of room that every young girl would have liked to have, and Caldecott furnished the room with paintings on the wall of Red Riding Hood, The Babes in the Woods, and Bo-Peep. Caldecott's enthusiasm for imagining a fun-filled world, where anything is possible, provided a much-needed endorsement of a child's lively imagination. This offered young readers the opportunity to see that there was nothing wrong with envisioning themselves as the kings and queens of their own imaginary kingdoms.

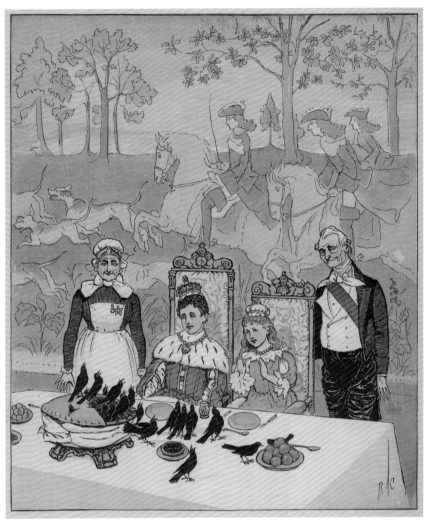

figure 18

In this book, one gets the sense that children are liberated, free to behave as adults. The story is quite literally told from the first-person perspective of children who are left alone to pursue grown-up activities. In an early scene, two children are shown with their backs to the reader while looking at a trap they have set to catch the "four-and-twenty" blackbirds that are needed to bake a pie. This convention of showing readers the backs of children creates the expectation of seeing something from the character's point of view. In this case, Caldecott successfully created a visual first-person perspective where the scene brings readers to the same level as the youthful characters. These children are clearly having a wonderful time, and Caldecott wanted his readers to share in that experience. Seeing the children laughing at their enormous pie, filled with lively blackbirds, is truly delightful. The scene is comical and lighthearted, and nowhere is the impression left that these characters are under some obligation to perform to a societal standard. They are there to have fun and to be themselves. This sense of emancipation from anything oppressive worked against the serious duty-ridden roles that were so consistently portrayed in children's fiction of the day. Caldecott's desire was to stimulate the young reader's imagination with the impression that children have unlimited potentialities. In that sense, he developed his own narrative formula away from the story-patterns of the Victorian moral tale, where the cultural messages passed on to children emphasized strict obedience, and he showed his young readers the world from a different, more liberated point of view.

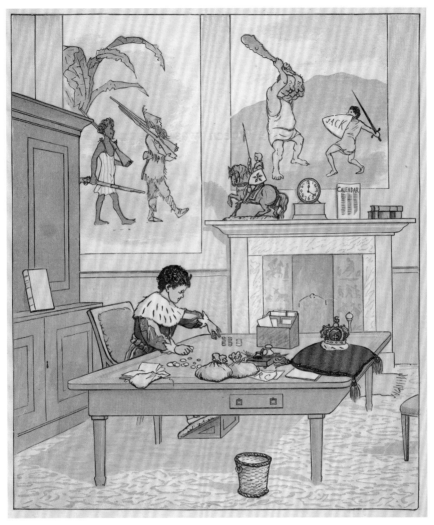

figure 19

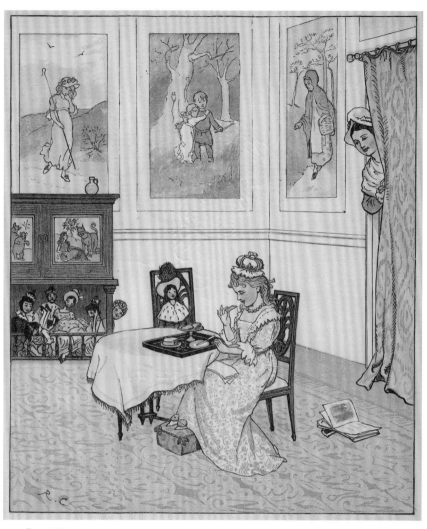

figure 20

8. The Three Jovial Huntsmen
Randolph Caldecott
London: George Routledge & Sons, 1880

Edwin Waugh, the prolific writer who enlisted Caldecott to illustrate a number of his books, modified his country story *Old Cronies* by adding rhymes from an old hunting song that was known for its humorous lyrics. Caldecott liked the story so much that he decided to design his own version. He supplied many wonderful illustrations for the rhyme and had it published as *The Three Jovial Huntsmen*. One of the most beautifully designed books in the series, this features nine full-page colour illustrations and twenty-three sepia illustrations. This was an instant success with its eye-catching, paperbound "yellow back" format and the striking image of the red-jacketed hunters on the cover (fig. 21) that was bold enough to be seen easily at the bookstalls on Britain's busy train platforms. Caldecott understood that his *Picture Books* had a better opportunity to sell briskly if they were packaged in a way that showcased their excellent aesthetic quality at a supremely competitive price. Evans played a crucial role in elevating the *Picture Books* to a sophisticated art form by showing time and again how colours could hold the eye and create interest. The three horses on the cover are especially handsome with their distinct shades. If readers look closely, they will see that Evans also took uncommon care to give each horse its own eye colour. Each wintry scene is made more enjoyable by the many wonderful shades that Evans used to breathe life into the fast-paced hunt. When readers come across the page where the hunters find a fat pig smiling in a ditch (fig. 22), they are sure to notice the many shades of pink flesh and russet-coloured dirt. Their eyes continue to follow the hunters as the day wears on and the skies become darker, and then they will notice in the final scene that the horses are all several shades darker than in their first appearance (fig. 23). Evans took the unusual step to keep the colours consistent with what would be seen in the real world under a fading sun, and along with Caldecott's strong lines, this title magnificently captures an authentic sense of what it meant to travel the fields, roads, and hills of the English countryside.

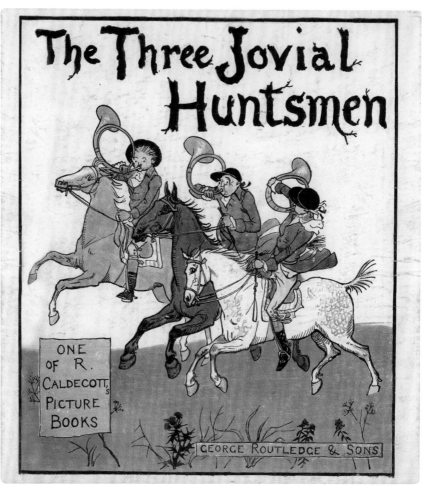

figure 21

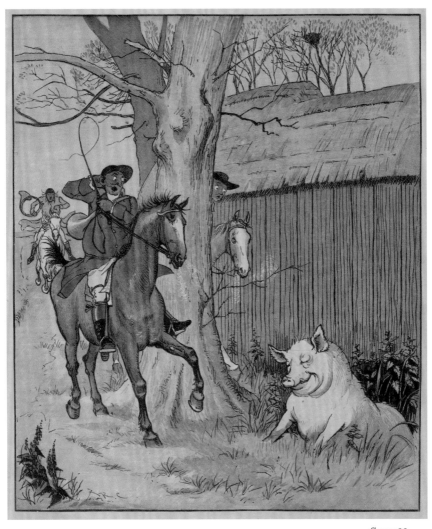

figure 22

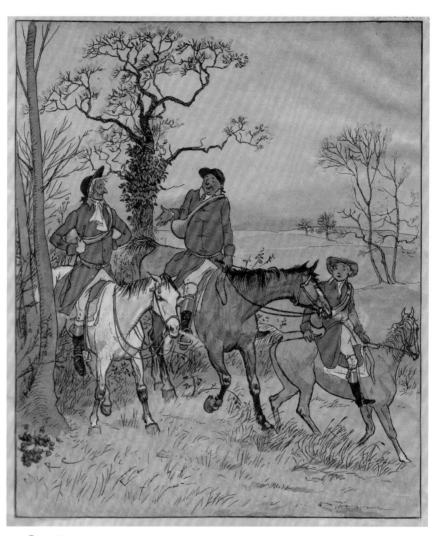

figure 23

figure 24

9. What the Blackbird Said:
A Story in Four Chirps
Mrs Frederick Locker
London: George Routledge & Sons, 1881

In addition to the beautifully designed illustration for the front cover (fig. 24), this features four black-and-white illustrations drawn by Caldecott. Routledge published the book with attractive navy cloth covers, and the title was stamped in gold. What makes the cover especially appealing is the vivid scene of three blackbirds, two stamped in black and one in gold, and the beautifully drawn branch that hangs over the birds. Caldecott used blackbirds quite often as subjects in his work for periodicals and book illustrations, and his oil painting, *The Three Ravens*, now in the Parker Collection at Harvard, instills a strong feeling that the artist was always in complete command of the birds' anatomical details and colours. Indeed, when one looks at the interior illustration entitled "The Robin's Nest", one is reminded that Caldecott had an uncanny ability to sketch all variety of birds with exacting realism (fig. 25). Caldecott was fascinated with the different shapes and sizes of birds (fig. 26), and he prepared wonderfully detailed illustrations that gave inspiration to his successors. Locker, an intimate friend of Caldecott's, must have been exceedingly grateful to her illustrator for attracting the attention of her readers with pictures of birds that may not have been seen or considered before. When they look at these pictures children can explore questions and ideas that they have about the mysteries of nature's creatures because Caldecott stimulated their eyes with images of birds going about their many activities in their natural habitat. What child is not curious about the way that a robin builds its nest or the manner in which blackbirds congregate and adapt to their environment? Caldecott's pictures show that birds have active and fascinating lives that are worthy of attention and appreciation.

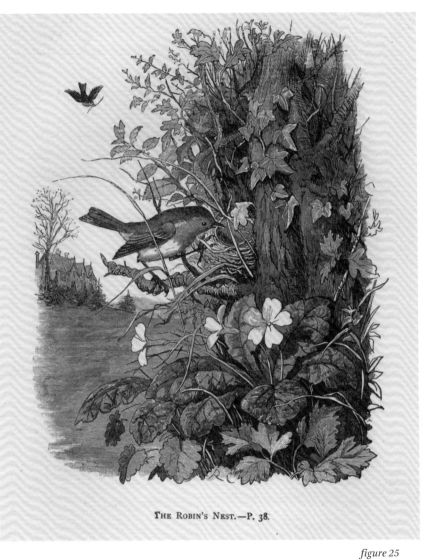

THE ROBIN'S NEST.—P. 38.

figure 25

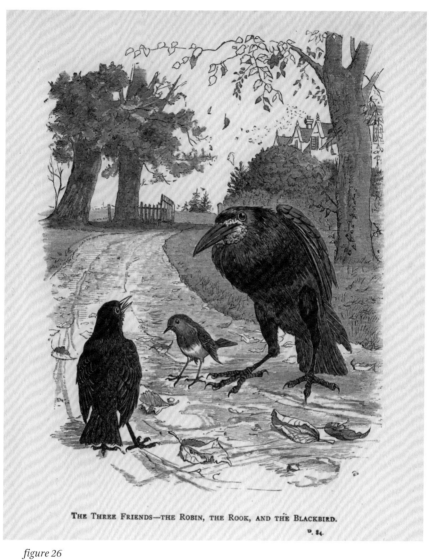

THE THREE FRIENDS—THE ROBIN, THE ROOK, AND THE BLACKBIRD.

figure 26

10. The Farmer's Boy
Randolph Caldecott
London: George Routledge & Sons, 1881

Caldecott adopted the "rural poem" of Robert Bloomfield (1766–1823) and turned it into his own pastoral tale populated with sizable numbers of sheep, pigs, turkeys, dogs, horses, ducks, hens, shepherds, and children. The numerous rustic scenes evoke the beautiful countryside near Whitchurch, where Caldecott spent his childhood. This book has become associated with Caldecott's love of animals and his extraordinary skill in depicting their various anatomies with exacting realism. His animals are highly expressive. The sheep on the front cover are particularly charming (fig. 27), and the three that peer directly at the reader look as if they have raised eyebrows. One can almost hear the pigs snorting and squealing as the young farm boy approaches with a pail of feed (fig. 28), and Caldecott clearly wanted his readers to enjoy the effects of texture and colour. The invitation to touch the animals is made all the more enticing by the way that Evans added as many as six colours on a single animal. The ducks and the hens, for example, are brought to life with colours that are near perfect reflections of the real animals. Other picture books being released by competing artists never offered the same sensuous experience. When one looks at Caldecott's line and linear emphases, colour and contrasts of tone, patterning, shapes, and character viewpoint, as well as how the animals are able to exemplify the real sense of being on a farm, it is not surprising that Caldecott became known for charging his stories with energy. Here we see Caldecott as a spontaneous artist who occasionally does the unexpected, such as one scene where a pig wears reading glasses and stares at letters of the alphabet that are strewn on the ground. Caldecott loved the country life, and this is the finest example of his passion for celebrating and immortalizing the English countryside. Whenever he could, he made an effort to replicate the charming pastoral scenes from his childhood (fig. 29). In that sense, he often looked to a picturesque and countrified past for inspiration in his art.

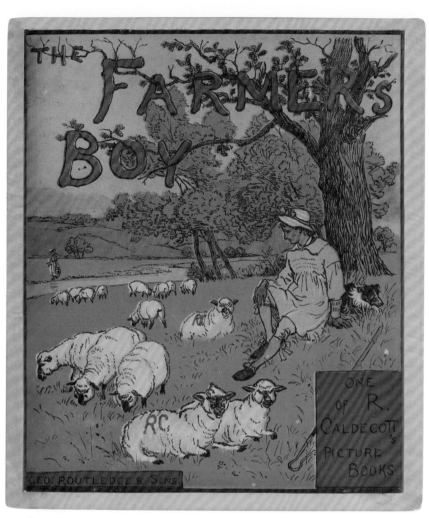

figure 27

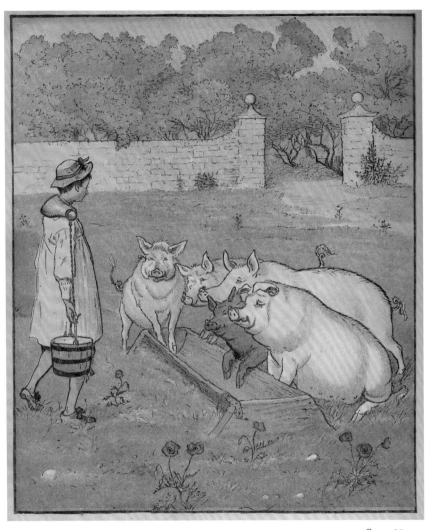

figure 28

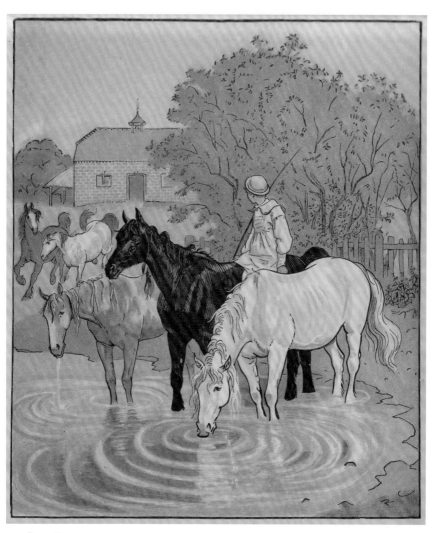

figure 29

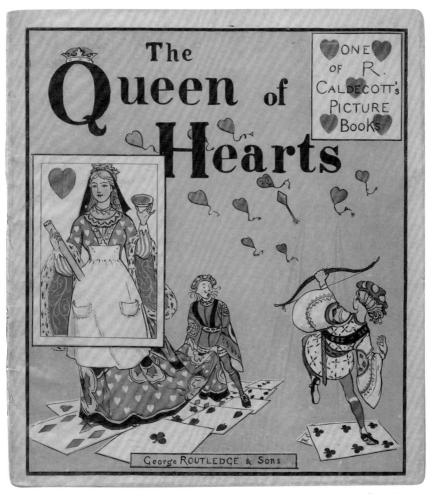

figure 30

11. The Queen of Hearts
Randolph Caldecott
London: George Routledge & Sons, 1881

The beauty of this picture book is particularly noteworthy. No finer example exists of Evans' strong influence on design, evident in the way that colours enhance the look and feel. The warm reds and browns invite eyes to linger on the decorative settings, while the subtle greens and blues add a wonderful sense of texture. Caldecott was fastidious about breathing new life into the familiar nursery rhyme with animated characters clothed in extravagant dress, and he had a particular talent for delighting children with irresistible adventure. Here lavishly attired courtiers leap across the page in scene after scene of spirited adventure. Caldecott instilled a sense of lively animation in the story of the Knave of Hearts who steals the Queen's freshly baked tarts (fig. 31), and the sense of urgency in recovering the tarts is reminiscent of a contemporary action-packed cartoon. This model of an accelerated and theatrical narrative is one of Caldecott's unique contributions to the picture book form. He loved to enrich classic nursery rhymes with a sense of impulsive action that was undoubtedly a novel and much appreciated form of entertainment for the children of his day. Readers of all ages have little trouble sympathizing with the outrage of the King who learns that one of his own courtiers has stolen the tarts. Caldecott captured his feelings of betrayal so perfectly in the wild contortions of his face. Caldecott clearly understood how to develop his characters, much as theatre directors guide their actors to portray a full range of emotions. Many critics were quick to identify Caldecott's sense of animation as a special talent. When young readers turn the pages of this book their eyes follow an elaborately comical nursery rhyme, told with only fifty-four words, that remains a perfect example of what Caldecott called "the art of leaving out as a science". Caldecott was not shy in testifying to his belief that "the fewer the lines, the less error committed". This theory was put to work in the many scenes where the depiction of the characters is always fresh and lively without ever appearing overworked. A later scene where the King sits down with his family to enjoy the tarts is particularily enchanting because we see the look of excitement on the children's faces (fig. 32).

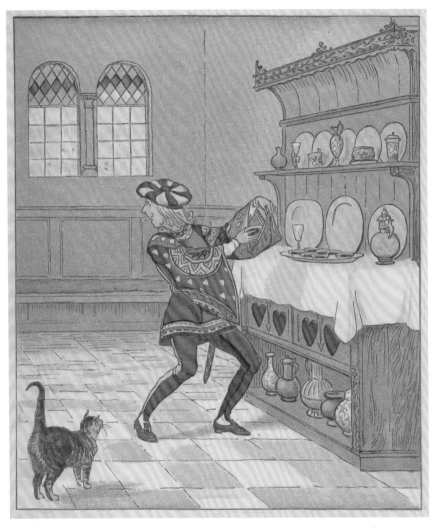

figure 31

50

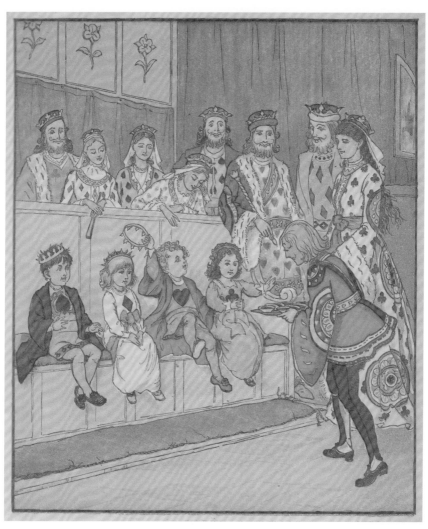

figure 32

12. The Milkmaid
Randolph Caldecott
London: George Routledge & Sons, 1882

Of all the wonderful books in the *Picture Books* series, this is the one title that probably garnered the most laughs from a young audience. *The Milkmaid* tells of a cocky young squire who sets out, at his mother's bidding, to find and marry a woman of good fortune (fig. 34). When readers turn the page to see that he finds a pretty young lady on his travels through the countryside, they probably think that he will sacrifice money for beauty (fig. 35). The young man appears entirely enthralled with the young lady until he asks about her father's position. When she explains that her father is a farmer, the brief courtship is promptly ended with the squire shouting, "Then I can't marry you, my Pretty Maid!" Caldecott provided a brilliantly entertaining full-colour illustration of the squire looking utterly disappointed, while the young milkmaid leans forward with a confident and playful smirk. Caldecott made the squire look rather feminine in his foppish pose and the way he is shown holding the tips of his fingers to his chin (fig. 36). This is Caldecott at his best, of course, because readers are given the opportunity to bring the scene alive in their own imaginations. Caldecott was a master at creating mood and tone, but he never made situations too obvious, thus allowing his readers to develop their own internal responses. The climactic moment occurs when the milkmaid declares, "Nobody asked you, Sir!" Caldecott escalated the humour in three successive scenes depicting the milkmaid and her two friends running after the squire (fig. 37), picking him up, and then throwing him on top of an angry cow. The three young ladies are shown laughing and dancing while the squire does what he can to ride the cow without being thrown off (fig. 38). Caldecott provided his readers with much amusement in these final scenes that flow together seamlessly like an engaging motion picture.

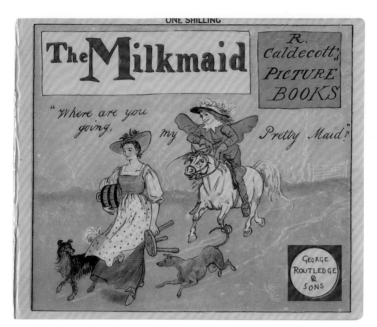

figure 33

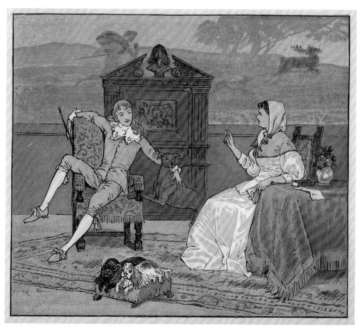

figure 34

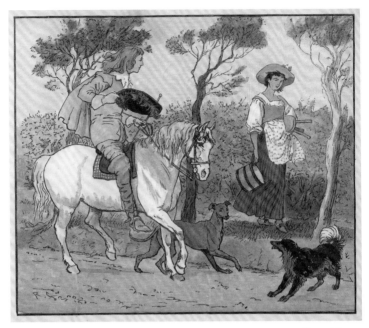

figure 35

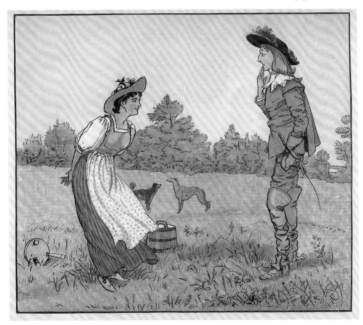

figure 36

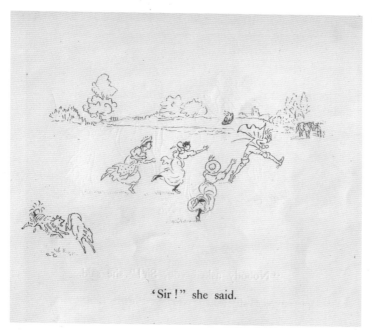

'Sir !" she said.

figure 37

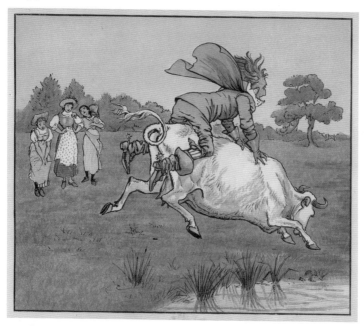

figure 38

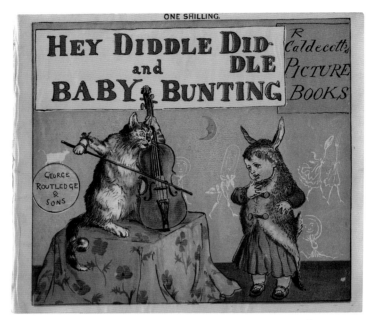

figure 39

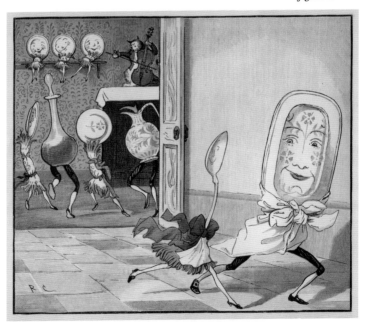

figure 40

13. Hey Diddle Diddle and Baby Bunting
Randolph Caldecott
London: George Routledge & Sons, 1882

This joins two sets of children's rhymes in one volume, and its value to readers is in the many fanciful scenes, like the moment when the cow jumps over the moon or the dish runs away with the spoon (fig. 40). Caldecott had a tremendous gift for working with only a handful of words and yet managing to develop the story with drawings that are filled with emotion. Readers are hard pressed to overlook the charged emotion in the scene where the daughter-spoon is accompanied by her angry father-knife and disappointed mother-fork. The enchantment of turning the page to find common barnyard animals behaving like regular country folk must have been magical and unforgettable for Caldecott's younger readers (fig. 41).

The story in *Baby Bunting* follows a less fanciful narrative thread: mother plays with her two boys (fig. 42) and father goes a-hunting, followed by a frantic scene where father hunts a rabbit skin for baby (fig. 43). Although the tale sounds rather uninteresting, Caldecott loved to do the unexpected. When father arrives home to wrap baby in the warm skin (fig. 44), readers are astonished with a final scene where baby takes a stroll through the countryside dressed as a rabbit. What makes the scene so surreal is the way that Caldecott overpopulated the landscape with lively rabbits, as if baby were simply one of the woodland creatures about to join his peers. Caldecott was a sophisticated artist and storyteller, and he often created moments where the narrative tone changed dramatically, like the sudden arrival of clouds signaling an imminent storm. This book is filled with scenes where baby changes its behaviour in dramatic ways, and these pictures show Caldecott as a theatrical person who loved his story to take unusual twists and turns.

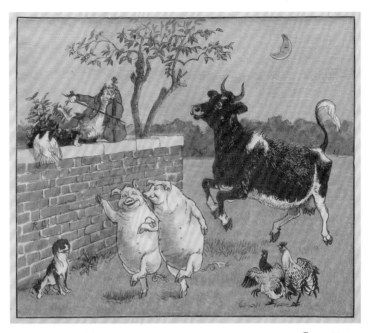

figure 41

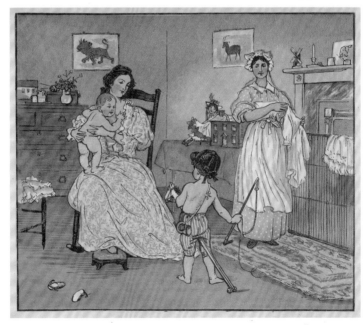

figure 42

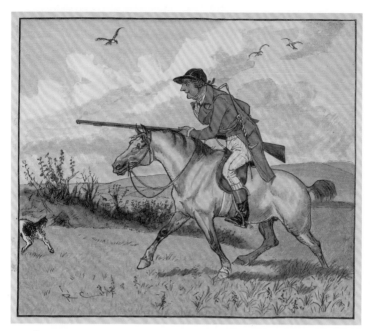

figure 43

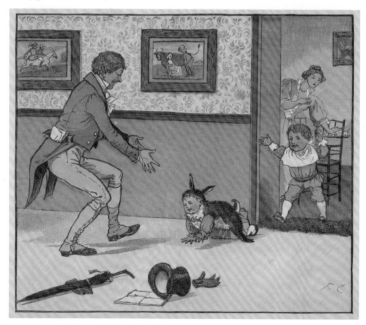

figure 44

14. Some of Æsop's Fables with Modern Instances Shewn in Designs by Randolph Caldecott
Æsop
London: Macmillan & Co., 1883

Macmillan published this title in April (reprinted in June) with a distinctive salmon-coloured cloth, which featured a throng of excited frogs and an enormous crowned stork stamped in dark brown on the front cover (fig. 45). An American limited edition of fifty copies was also published in New York by Macmillan, which featured hand-coloured illustrations. Caldecott worked on the illustrations throughout 1874 and 1875, and he acquiesced to the suggestion of his engraver, James Cooper, that he create "modern instances" for the *Fables*. Cooper likely felt that the book would have a novel appeal if readers were to see drawings of contemporary characters and scenes to complement the text. Caldecott's brother Alfred wrote the book, and his feeling about Cooper's suggestions is best reflected in the book's prefatory note where he makes it clear that he had hoped to produce an authentic translation from the Greek, Roman, and French originals.

> The Translations aim at replacing the florid style of our older English versions, and the stilted harshness of more modern ones, by a plainness and terseness more nearly like the character of the originals...in the collaboration the Designer and Translator have not been on terms of equal authority; the former has stood unshakeably by English tradition, and has had his own way. (*Some of Æsop's Fables*, prefatory note)

Clearly, Alfred was not keen on the idea of including illustrations from contemporary political or social circumstances in Victorian life. Alfred taught English literature at St John's College, Cambridge, and obviously he felt that his brother's handling of the classic material was problematic. He probably had a certain satisfaction in learning that Randolph was utterly disappointed

figure 45

by his decision to contemporize the *Fables*, which was evident in Randolph's letter to a friend: "Do not expect much from this book. When I see proofs of it I wonder and regret that I did not approach the subject more seriously" (Blackburn, 96). Despite Caldecott's personal disappointment, the book has tremendous appeal to younger readers for its many beautifully drawn animals and comical scenes. The illustration of the man who has two wives is particularly humorous because the man is shown collapsed on the floor between two imposing female statues, one named "Real" and the other "Ideal".

Caldecott created a unique embellishment of the ancient fables with illustrations inspired by his keen observations of the English farmlands. The many exemplary sketches of birds and animals provide much inspiration for the youthful imagination. Joseph Pennell, the virtuoso American etcher and critic, wrote of his great fondness for the magnificent animals in Caldecott's *Æsop*: "It would be almost impossible to give a better idea of bounding free motion than in this stag from the *Æsop*, with the whole of Scotland stretching away behind him, though probably the lines in the shadow were better in the original drawing" (Pennell, 231). Pennell also wrote enthusiastically about the childlike innocence of the depiction of the lamb before he encounters the wolf (fig. 46). Paul Gauguin also spoke admiringly of the various animals in Caldecott's *Æsop*: "That was the true spirit of drawing" (Hartrick, 33). Indeed, Caldecott's special talent for portraying the subtle emotions and the explicit physical behaviours of the animal kingdom was incomparable. An abundant collection of Caldecott's preliminary sketches for the *Æsop* can be found in the Victoria and Albert Museum in London.

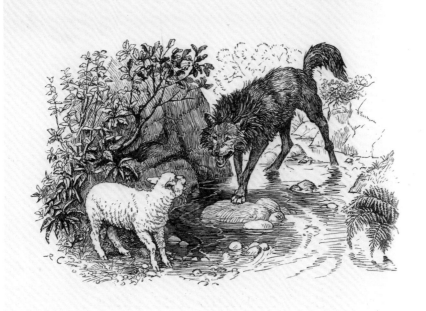

THE WOLF AND THE LAMB.

A WOLF seeing a Lamb drinking at a brook, took it into his head that he would find some plausible excuse for eating him. So he drew near, and, standing higher up the stream, began to accuse him of disturbing the water and preventing him from drinking.

The Lamb replied that he was only touching the water with the tips of his lips; and that, besides, seeing that he was standing

figure 46

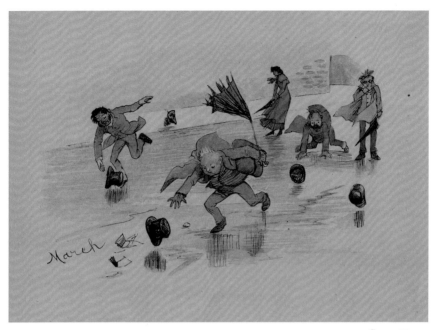

figure 47

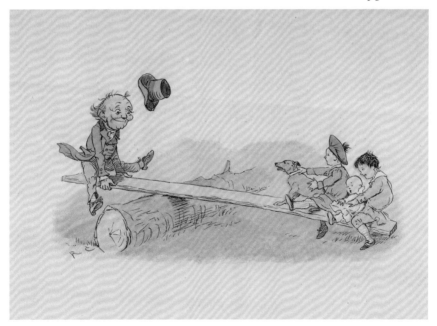

figure 48

15. A Sketch-Book of R. Caldecott's

Randolph Caldecott

London: George Routledge & Sons, 1883

This exceptional book of forty-eight pages of colour illustrations, engraved and printed by Edmund Evans, had an initial print run of 4,000 copies.[4] Curiously, it was under-appreciated when it was published. Evans wrote in his *Reminiscences*, "The R.C. *Sketch Book* was not a success; why, I never could understand" (Evans, 59). Victorian readers may have expected something more along the lines of Caldecott's popular *Picture Books*, but no nursery rhymes are here to enjoy. Rather, the *Sketch-Book* is about the four seasons— spring, summer, autumn, and winter—and if the book had been packaged with a vibrantly illustrated front cover, children would surely have accepted it as joyfully as any of Caldecott's nursery rhyme titles. Instead, Evans designed the book with a handsome, but rather subdued brown cloth. It certainly appeared to be the kind of book that would sit on a desk or a formal table to be appreciated by refined adults. The back of the title page shows a single sentence facsimile of Caldecott's humorous dedication: "Dedicated to everybody—but copyright reserved". Below the dedication is yet another example of Caldecott's finely drawn horses; in this case, the handsome beast is mounted by a courtly knight with a curious smirk on his face. Once again, readers see how Caldecott enjoyed adding light-hearted features to his drawings. Evans added exquisite touches of colour throughout the book to capture the changing of the seasons and the subtle shades of flourishing foliage.

The *Sketch-Book* has a good deal which can be enjoyed by younger readers, including the comical spring scene where the townsfolk chase after their hats on an exceptionally windy day (fig. 47) or the picture of the leprechaun who falls off a seesaw while playing with several happy children (fig. 48). Many additional scenes are shown from a child's viewpoint. Young boys would certainly revel in the opportunity to see the two full-page colour illustrations of boys dressed up as soldiers and preparing for mock battles (fig. 49). Young girls, on the other hand, would delight in the summer tea party (fig. 50). Young or old, readers can appreciate the *Sketch-Book* as an intimate pictorial account of Caldecott's obvious fascination with every curious spectacle, including lively parties (fig. 51) and fanciful costumes (fig. 52).

Review of the Household Troops.
The Cavalry.

figure 49

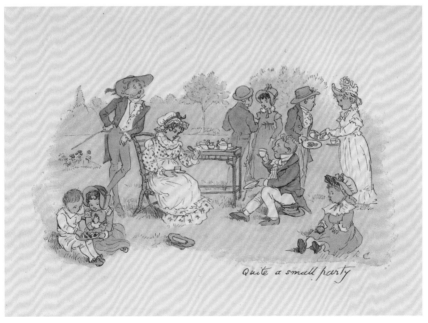

Quite a small party

figure 50

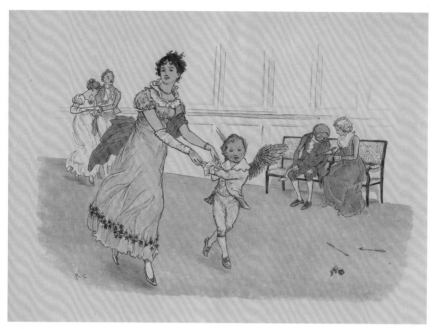

figure 51

figure 52

16. Jackanapes
Juliana Horatia Ewing
London: Society for Promoting Christian Knowledge, 1883

The Society for Promoting Christian Knowledge, a leading and highly industrious publisher of religious books and popular fiction, published *Jackanapes* with seventeen full-page and small black-and-white illustrations by Caldecott. Juliana Horatia Ewing had immense admiration for Caldecott's work, largely attributed to his illustrations for Washington Irving's *Old Christmas* (1875) and *Bracebridge Hall* (1877). When Ewing met Caldecott in June of 1879, she asked him to provide a colour illustration for *Jackanapes*. She was an enormously respected children's author, and Caldecott was pleased to produce a picture to accompany one of her scenes. The illustration of a "fair-haired boy riding a red-haired pony" was the result of their initial agreement—as described by Ewing's sister and biographer, Horatia Katharine Frances Gatty—and was initially given to *Aunt Judy's Magazine* along with the story before it was re-published in book form in 1883.[5] Horatia's description of the publication of *Jackanapes* is particularly insightful.

> The first copies were brought out in dull stone-coloured paper covers, and that powerful vehicle the Trade, unable to believe that a jewel could be concealed in so plain a casket, refused the work of J.H.E. and R.C. until they had stretched the paper cover on boards and colored the Union Jack which adorns it! No doubt the Trade understands its fickle child, the Public, better than either authors or artists do, and knows by experience that it requires tempting with what is pretty to look at before it tastes. (Davis, 36)

Ewing described the cover of *Jackanapes* (fig. 53) as "its one blemish" in a candid letter to Caldecott (Hutchins, 111). The cover of *Jackanapes* bears little resemblance to the vibrant covers of the *Picture Books*, but despite this disparity children have much to enjoy in the interior illustrations. Caldecott's talent for communicating the art and humour of the story is

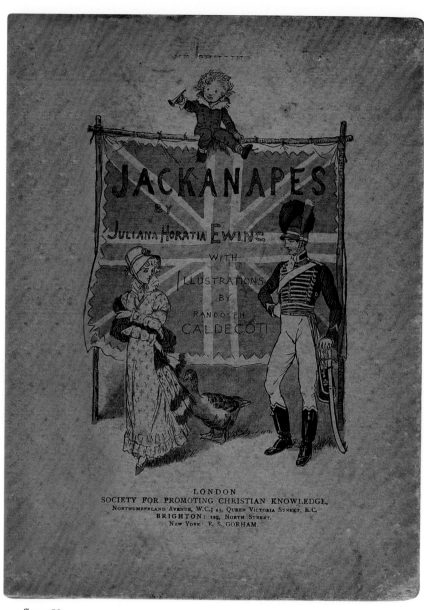

figure 53

once again at work in *Jackanapes* as children are urged to participate imaginatively in many playful scenes that are faithful to photographic reality. The illustration in the third chapter of a boy and girl seated on wooden ponies while enjoying a ride on the revolving carousel is especially captivating for the young reader (fig. 54). A few pages later, another child is seen riding a real pony while his family looks on encouragingly. In a very explicit manner, Caldecott's illustrations give resounding encouragement to young readers to go out and have fun. In fact, Caldecott is at his best with these lighthearted illustrations that speak directly to the innocent yearning of children to break free of the burdens connected with growing up.

the fifth he had laid his yellow head against the Black
Prince's mane, and so clung anyhow till the hobby-horses
stopped, when the proprietor assisted him to alight, and he
sat down rather suddenly and said he had enjoyed it very
much.

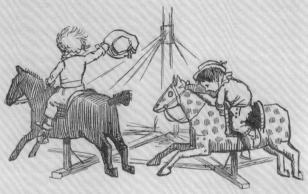

The Grey Goose always ran away at the first approach
of the caravans, and never came back to the Green till
there was nothing left of the Fair but footmarks and
oyster-shells. Running away was her pet principle; the
only system, she maintained, by which you can live long
and easily, and lose nothing. If you run away when you
see danger, you can come back when all is safe. Run
quickly, return slowly, hold your head high, and gabble as
loud as you can, and you'll preserve the respect of the
Goose Green to a peaceful old age. Why should you
struggle and get hurt, if you can lower your head and
swerve, and not lose a feather? Why in the world should
any one spoil the pleasure of life, or risk his skin, if he can
help it?

> " ' What's the use?'
> Said the Goose.' "

figure 54

71

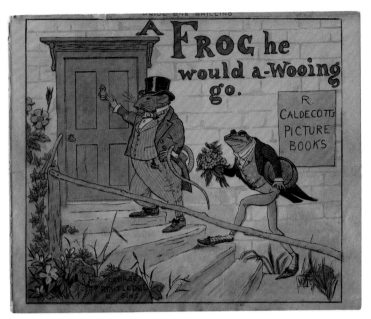

figure 55

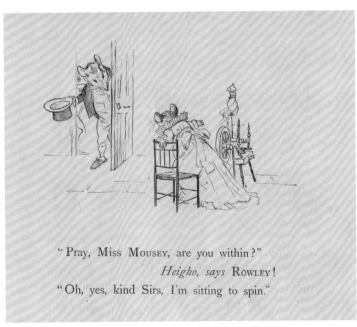

"Pray, Miss MOUSEY, are you within?"
 Heigho, says ROWLEY!
"Oh, yes, kind Sirs, I'm sitting to spin."

figure 56

17. A Frog He Would a-Wooing Go
Randolph Caldecott
London: George Routledge & Sons, 1883

With the release of the last handful of titles in his *Picture Books* series, Caldecott finally secured a more profitable arrangement with his publisher. This unusual story is about a courtship between a dapper gentleman-frog and a pretty mouse. A gregarious beer-drinking rat facilitates the introduction (fig. 56), and a lively party ensues where Miss Mouse serves up a lavish meal and entertains her guests with drinks and music (fig. 57). Everyone proceeds to have a wonderful time over the course of a picture-perfect afternoon, with the rat standing up to make a toast and the frog enjoying a lively jig, but Caldecott provided an odd twist when a family of cats suddenly pounced on the unsuspecting merrymakers (fig. 58). The rat and the mouse are mauled to death and the frog makes a quick escape through an open window only to be pursued and eventually gobbled up by a ravenous duck (fig. 59). From this absurdity and silliness, readers turn the page to find a wonderful resolution to the loss of three friends (fig. 60). A family is pictured in the final scene casting their eyes on the pond where the frog perished, and the children look as if their parents just finished explaining how loss is simply a part of the beautiful cycle of life. The way that Caldecott provided an opportunity for children to learn about life's unexpected tragedies is one of his unique contributions to the picture book tradition. He wanted his young readers to take great pleasure in a dramatic story, but not without seeing the beauty that is often born out of catastrophe.

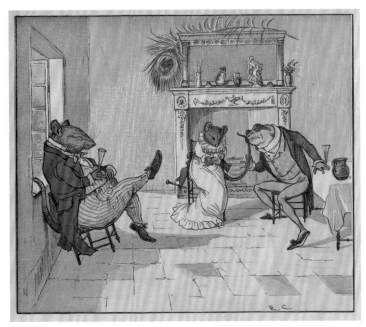

figure 57

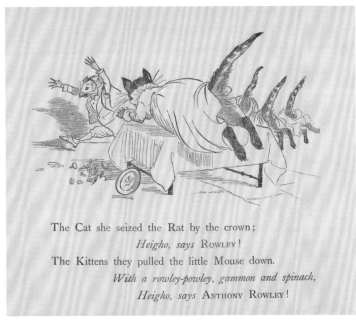

The Cat she seized the Rat by the crown;
Heigho, says ROWLEY!
The Kittens they pulled the little Mouse down.
With a rowley-powley, gammon and spinach,
Heigho, says ANTHONY ROWLEY!

figure 58

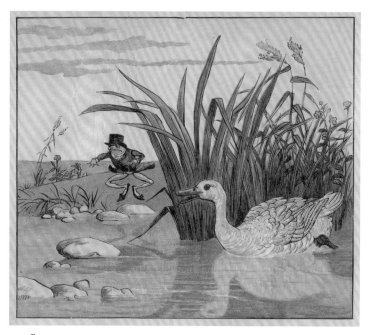

figure 59

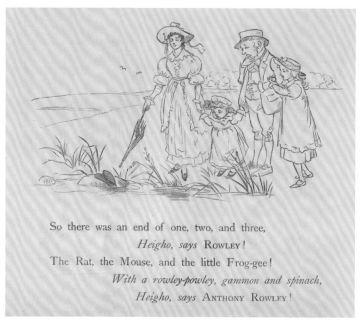

So there was an end of one, two, and three,
 Heigho, says ROWLEY!
The Rat, the Mouse, and the little Frog-gee!
 With a rowley-powley, gammon and spinach,
 Heigho, says ANTHONY ROWLEY!

figure 60

18. The Fox Jumps over the Parson's Gate
Randolph Caldecott
London: George Routledge & Sons, 1883

The content of this book was commonly seen in the form of a song in Victorian music books. Caldecott complemented what is essentially a hunting story with illustrations that celebrate quickness and motion. After readers put this book down they are probably hard pressed to recall any particular picture. What they are likely to remember, however, is the rhythmic procession of characters that bound across the page: white horses with scarlet-coated riders (fig. 62), a bushy-tailed fox leaping over a fence, an inquisitive priest pressing his ear to the church window, amorous couples, lively drinking companions, and a final scene where someone sings "Tally-ho!" while the crowd performs a jig. Caldecott achieved an effect of perpetual movement that stimulates children to observe how humans and animals make their way through the busy world. Young children would certainly enjoy watching closely for visual clues about shapes and colours that move from one point to another. The scenes are full of chaotic action that depicts events from everyday life, but Caldecott strung the scenes together in a way that encourages children to participate in the book rather than simply admiring its pictures. One has a sense of riding along with the hunters and the eager hounds as they gallop through the fields and over the parson's gate (fig. 61). The scene of the fox frozen in midair over the white gate is like a snapshot that encourages a child's eyes to linger for a moment on the ensuing pandemonium (fig. 63). They see the gasp of an elderly woman who drops her planting pot while her friend stares in amazement at the high-spirited fox. The facing page immediately continues the motion a moment later as it shows the pack of yelping hounds in hot pursuit (fig. 64). The old woman has by now collapsed to the ground and her younger friend has run away in a state of panic. This brisk and entertaining action is what endears Caldecott to children, who certainly picked up this book over and over again to partake in the fun of a frenzied fox hunt. Of course, children can also take pleasure in watching grown-up activities like the hunters' celebratory meal (fig. 65) and their merry jig (fig. 66).

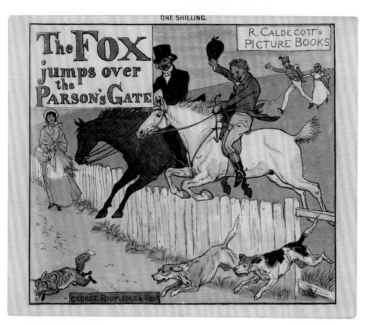

figure 61

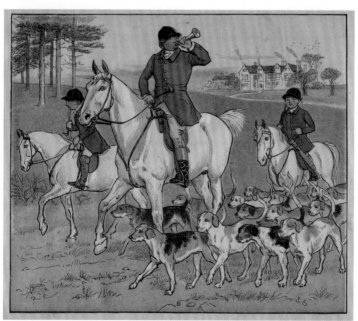

figure 62

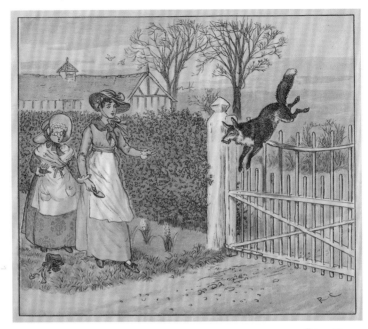

figure 63

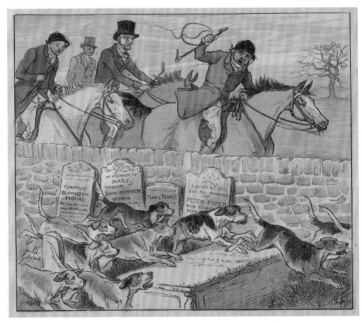

figure 64

figure 65

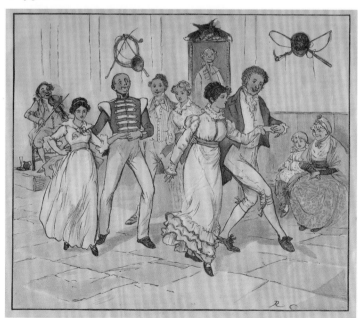

figure 66

figure 67

figure 68

19. Come Lasses and Lads
Randolph Caldecott
London: George Routledge & Sons, 1884

The content of this book can be traced back to a popular song from the late seventeenth century. Caldecott added additional verses to extend the rhythm and musical qualities of the dance that ensues around the Maypole. Readers are easily caught up in the festivities from the moment they see the opening full-page colour illustration of a procession of well-dressed townspeople walking toward the tall Maypole (fig. 68). Caldecott clearly wanted readers to feel like they, too, were invited to attend the party. In fact, one young man is seen turning his head and looking back, not at the young ladies behind him, but at the reader. "Come along and join us", he seems to say. Caldecott drew out every nuance of meaning in his scenes so that his readers could appreciate the emotions and thoughts of every character, no matter how minor, along with the ramifications of each gesture. On the next page, young readers would certainly pity the young ladies who are pictured listening to their father as he raises a single reproving finger in the air (fig. 69). He appears to be cautioning the young ladies to be careful at the May Day celebrations and to return at a reasonable hour. What makes the illustration so meaningful to a child is the simple gesture of the raised finger; it probably made the respectful Victorian child shudder at the thought of disobeying such an austere father.

The colour illustrations are exceedingly beautiful and could easily be hung on the wall to be admired like first-rate portraits. Caldecott had some grievances, though, with the quality of the printing. In a letter to Evans, he complained about the lack of delicacy in some of the lines.

> And I cannot understand—as I told you—how those eyes in the key-blocks of 2 or 3 of the pages in Picture Books came so dimly—and the lines on one girl's dress on p. 3 of *Come lasses* came out not at all. This is, I suppose—or rather, faintly conjecture, the result of trying to keep the

Come Lasses and Lads, get leave of your Dads,

And away to the May-pole hey:

figure 69

"Good-night," says Harry; "Good-night," says Mary;
"Good-night," says Dolly to John;
"Good-night," says Sue, to her sweetheart Hugh,
"Good-night," says everyone.

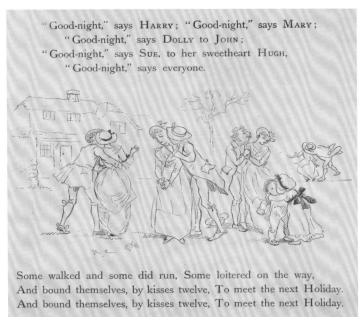

Some walked and some did run, Some loitered on the way,
And bound themselves, by kisses twelve, To meet the next Holiday.
And bound themselves, by kisses twelve, To meet the next Holiday.

figure 70

lines and dots light in the engraving—altho' the girl in last coloured page but one of *Come lasses* was meant to have dark eyes. (Hutchins, 73)

Despite these minor criticisms, the inviting scenes in *Come Lasses and Lads* never fail to transport children to that charming garden spot in May where Caldecott pointed out all the ways that children can have fun. Young boys probably squirmed, however, when they looked upon the scene where a young girl smothers an unsuspecting boy with a surprisingly passionate kiss (fig. 70). Young readers who did not like a particular picture or incident had the freedom to turn the page to find many other irresistible scenes where children are shown playing games or laughing with each other. Whatever moment is enjoyed the most, this book leaves a vivid memory with every child who gazes upon it, and they are sure to remember Caldecott's gift of illustrating a very social world where children concentrate their energies on recreation and merrymaking.

20. Ride a Cock Horse to Banbury Cross & A Farmer Went Trotting upon His Grey Mare
Randolph Caldecott
London: George Routledge & Sons, 1884

Ride a Cock Horse is a classic Mother Goose rhyme, told here with only thirty-three words and an energetic pacing of stunning illustrations. The front cover shows that Caldecott worked very hard to capture the dazzling beauty of a young lady riding a white horse, but his delicate lines created a significant challenge for the engraver (fig. 71). When one looks at the inside colour picture of the elegantly dressed young lady sitting upon her horse, one is immediately struck by the range of textures (fig. 72). Readers get a sense that they can almost reach out and run their fingers through the horse's mane, and they appreciate the sense of realism in the billowing clouds of dust that race up from the horse's hooves. Caldecott's engravers had no easy task in replicating the full range of textures that was necessary to make the scenes look so realistic. Evans was fastidious, however, in creating texture with expert hatching and stippling, and readers see the sophisticated effects of these incised lines especially in the young lady's elaborate hat, flowing hair, and elegant gown (fig. 73). Evans was still printing the *Picture Books* from boxwood, and this made it very difficult to achieve all of the fine detail that made these illustrations so appealing. The colour illustrations in this book testify to Evans' exceptional skill in replicating Caldecott's tightly packed lines. The sepia illustrations are also a delight to behold, and Caldecott took great care to give meaning to the most trivial details in every setting. The scene where the lady walks down the stairs is particularly amusing because we see all the peculiar behaviour of the dutiful servants, including the portly footman who ogles the lady's posterior (fig. 74). In a later scene where children ride their hobby-horses, Caldecott included enough detail for us to appreciate the thrill and enchantment of make-believe play (fig. 75).

A Farmer Went Trotting upon His Grey Mare is a simple story of a portly farmer who takes his daughter for a horse ride on a bumpy dirt road (fig. 76). They later fall off the horse when

figure 71

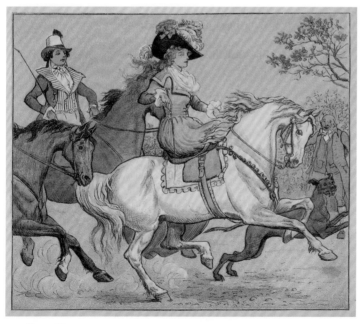

figure 72

they pass a large raven that cries "Croak!" (fig. 77). The mischievous raven laughs at the sight of the daughter applying a bandage to her father's head, and the story ends when the farmer walks into town holding the hand of his daughter (fig. 78). What makes this story so appealing is Caldecott's wry sense of humour. Clearly, Caldecott was willing to present his characters in comical situations where we are reminded how good it feels to laugh at the silly things that happen to us every day. The farmer is not terribly hurt in this story, but the picture of his daughter wrapping an enormous bandage around his head is rather absurd. This book has significant meaning for children because the child assumes the adult role, and Caldecott reminds his young readers that they, too, have important roles to play.

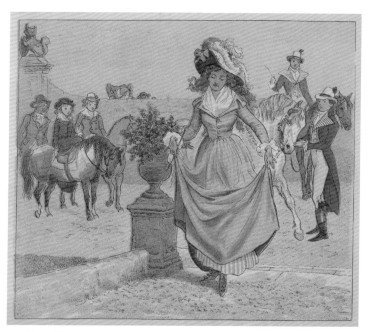

figure 73

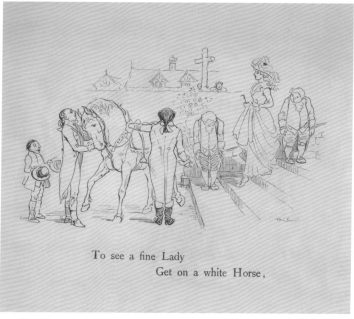

To see a fine Lady
Get on a white Horse,

figure 74

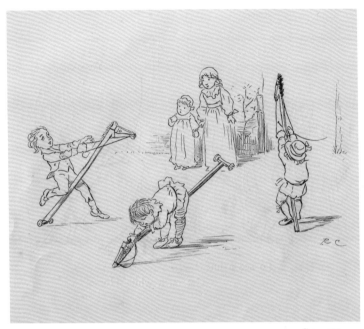

figure 75

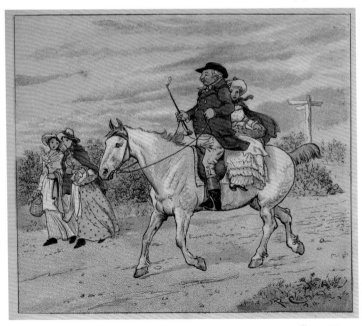

figure 76

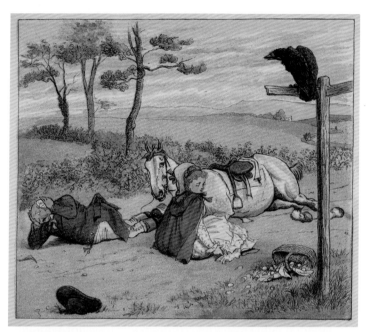

figure 77

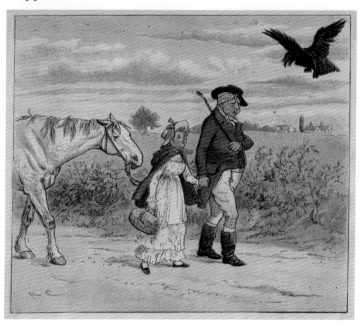

figure 78

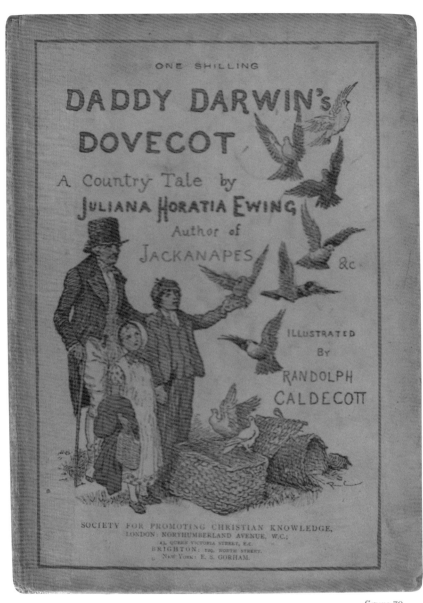

ONE SHILLING

DADDY DARWIN'S DOVECOT

A Country Tale by
JULIANA HORATIA EWING
Author of
JACKANAPES &c

ILLUSTRATED
BY
RANDOLPH
CALDECOTT

SOCIETY FOR PROMOTING CHRISTIAN KNOWLEDGE,
LONDON: NORTHUMBERLAND AVENUE, W.C.;
43, QUEEN VICTORIA STREET, E.C.
BRIGHTON: 129, NORTH STREET.
NEW YORK: E. S. GORHAM.

figure 79

90

21. Daddy Darwin's Dovecot: A Country Tale

Juliana Horatia Ewing

London: Society for Promoting Christian Knowledge, 1884

As they look at the pictures in this book, readers may not be too surprised to learn that Caldecott's pocket notebooks are filled with all varieties of bird illustrations, and many of them have penciled notes that make clear what kinds of modifications he wanted to make for the final drawings that would eventually populate the pages of books like *Daddy Darwin's Dovecot*. Caldecott had a special fondness for birds—they are everywhere in his books—but some of his best work is seen here in the truthful representations of storks and pelicans. His expertise in replicating their natural beauty can be at least partly credited to the many hours that he spent studying mounted specimens in museum collections. He was wholeheartedly committed to these regular museum visits, and not even the Christmas holidays interrupted his efforts as we see in a 24 December 1874 diary entry where he indicated that his time was spent in the caverns of the British Museum, making a drawing, and measuring a skeleton of a stork (Blackburn, 115). *Daddy Darwin* features seventeen full-page and small illustrations by Caldecott, and Evans completed the printing and engraving. In Caldecott's letters about the work he did for *Daddy Darwin*, we are given some insight into the troubles that Evans had in the reproduction of illustrations between 1880 and 1890 when photographically prepared process plates were replacing wood engravings. In a letter to Evans, Caldecott indicated his discontent with the effects of imperfect process techniques for *Daddy Darwin*: "The illustrations in that book—some of 'em—do not come out very well. The children a-singing especially" (Hutchins, 48). Evans used a process reproduction for the front cover and interior illustrations, but he engraved the design on wood for the title page. The poor illustrations that Caldecott referred to are very likely the result of faulty electrotypes. In a letter dated 22 August 1884, Caldecott wrote to Ewing that he wanted Evans to engrave the title page to ensure high quality.

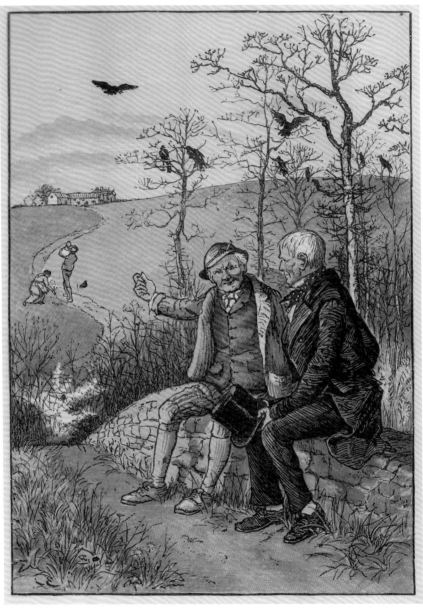

figure 80

I have—perhaps you have also—told E. Evans that you want the frontispiece to D.D.D. printed in colour. He is going to use a *process* reproduction of title for cover and engrave the design on *wood* for title page. (Hutchins, 116)

Caldecott expected to be disappointed by the reproduction results, and he worked with Evans to "touch" the process blocks to ensure that the beauty of certain illustrations equaled what he would have expected with wood engraving. Ewing was less than satisfied with the process results, and she suggested to Caldecott in a letter dated 7 December 1884 that Evans must work harder to satisfy their expectations "on pain of moving elsewhere" (Hutchins, 129). To make matters worse for Caldecott and Ewing, Evans made the uncommon mistake of printing the book in dark black ink instead of the special shade of brown that had been insisted upon by Ewing.

22. An Elegy on the Glory of Her Sex: Mrs. Mary Blaize
Randolph Caldecott
London: George Routledge & Sons, 1885

Oliver Goldsmith (1730–1774) is the original author of this satirical story. Caldecott was attracted to its biting commentary about a flagrant harlot who sells her wares in a quaint eighteenth-century town. Caldecott's younger readers probably failed to notice the satire, but the illustrations are highly suggestive of a woman who has something to hide. The scene where Caldecott has her falling asleep in church is particularly beguiling (fig. 82); mature readers likely assumed that Mrs Blaize was exhausted from staying up all night with amorous company. This is an unusual title in the *Picture Books* series, for what could be construed as mature content was not exactly suitable for a younger audience, but the story can also be read literally, thus having the effect of a completely innocent and rather innocuous story. Read literally, Mrs Blaize is simply a respectable woman who gives to the poor and wears the latest fashions, and the snickering men in the street "who spoke her praise" are simply complimenting Mrs Blaize on her pleasant demeanour. For others, however, those same men are rather lusty in a "wink-wink nudge-nudge" sort of way; in fact, one is shown pointing his thumb in the direction of a shop sign reading "Blaize" with an attractive young woman standing underneath (fig. 83). The shop, of course, is a well-known brothel, and Caldecott made no pretense of hiding that fact from his readers in the many scenes where he portrayed the goings-on of a lively bawdy house. Victorian sensibilities were surely piqued by the scene where Mrs Blaize is seen behind her shop counter with watch in hand as she converses with a well-dressed gentleman (fig. 84). Caldecott made the scene so contentious in the way that he included women's undergarments and gowns hanging on the wall behind Mrs Blaize. Younger readers probably overlooked the gentlemen's overcoats that were also hanging on the far side of the room. Clearly, the gentleman was making arrangements for an amorous rendezvous. Or was he? Caldecott included another

figure 81

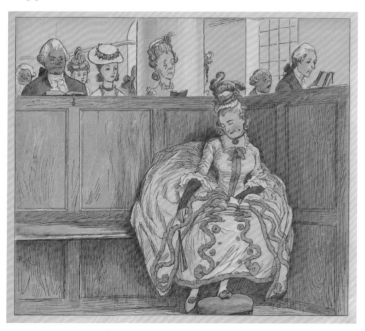

figure 82

illustration on the opposite page with another gentleman standing in front of the counter looking at a neatly folded vest; the text under the picture claims that Mrs Blaize "freely lent to all the poor". Caldecott ingeniously included pictures of two different gentlemen in two different circumstances; readers are left to judge for themselves the exact circumstances of what is going on in the mysterious shop.

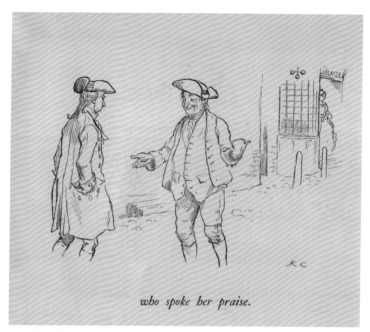

who spoke her praise.

figure 83

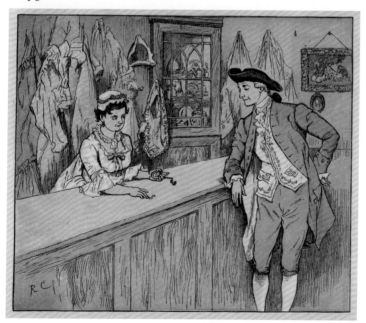

figure 84

figure 85

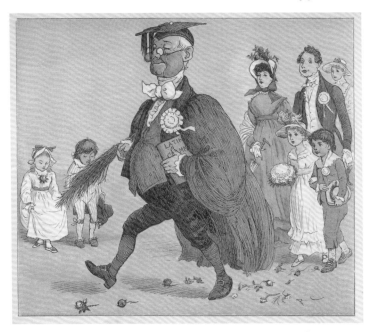

figure 86

23. The Great Panjandrum Himself
Randolph Caldecott
London: George Routledge & Sons, 1885

The playwright Samuel Foote (1720–1777) first wrote this some-what whimsical story of a frumpy academic who is continually teased by restless children. Foote's version was entirely satirical, though, and he used the story to poke fun at the actor Macklin, famous for his claims of being able to memorize lengthy soliloquies without difficulty or delay. Caldecott's retelling captures the essence of the original satire with his comical illustrations of the know-it-all professor (fig. 86). The front cover is particularly amus-ing with its scene of the professor who writes a long note on the chalkboard as a young boy simultaneously draws a picture of the unsuspecting professor's chubby face (fig. 85). The professor is made to look far more ridiculous in the final scene where he fails miserably in the popular eighteenth-century game of "catch-as-catch-can" (fig. 87) and later collapses on the floor from physical exhaustion. The book contains a number of charming scenes from Whitchurch, where Caldecott spent a good portion of his youth, and many admiring readers wrote to say that they recognized prominent features of their cherished town. Undoubtedly, these readers would not have recognized the many oddball characters who populate the town. Caldecott loved to highlight the eccentricities of these farcical characters with outlandish facial gestures and peculiar body language. The bar-bershop scene is especially entertaining with the confident young girl who prepares a bowl of shaving cream as three bearded men look on, doubtful of her ability to do the job (fig. 88). More confusion erupts when readers discover a great she-bear dressed in a full gown sauntering down the streets and poking her head in various shops (fig. 89). Caldecott made the most of the strangeness of the tale by including several more scenes where the reader's sense of normalcy is slightly skewed by bizarre characters or circumstances. The picture of the deceased clown slumped down in his kitchen chair is strange enough (fig. 90), but then readers learn that the cause of his death was his wife's failure to purchase a bar of soap to wash his clothes. Nothing makes sense, but this is where Caldecott's talent shines in his ability to make a really funny picture book out of pure gibberish.

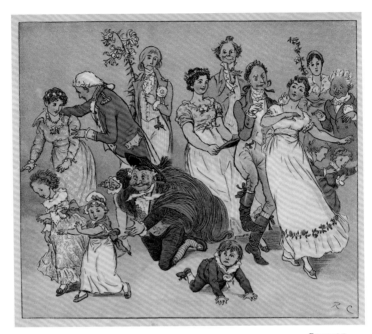

figure 87

figure 88

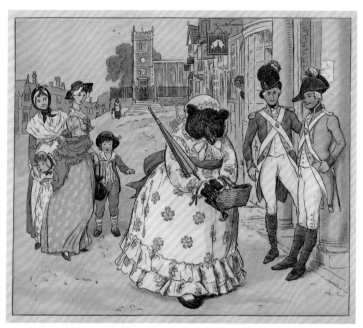

figure 89

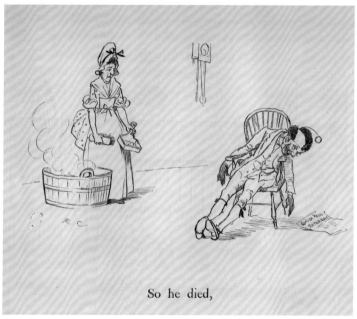

So he died,

figure 90

24. Lob Lie-by-the-Fire
or The Luck of Lingborough

Juliana Horatia Ewing
London: Society for Promoting ChristianKnowledge, 1885

This book includes four full-page and fifteen small brown illustrations by Caldecott, and Evans completed the engraving. Published with beige paper pictorial boards, this Juliana Ewing book sold for one shilling. An American edition was published simultaneously by E. & J.B. Young & Co. in New York. The illustrations are a fine example of the peculiar fitness of Caldecott's imagination for the entertainment of young readers. The spirit of children is very much at work in the drawings, with the visual narrative consistently told from the child's point of view. Young boys were surely tickled by the picture of young John Broom lying in the straw with his back against a white cow, moments after his escape from an angry farm bailiff. Finding a quiet place to get away from the pressures of life is a classic and familiar pleasure among young boys, and the drawing relates so immediately to that shared experience. As children continue reading, they come across another picture of John Broom, this time placing his hand inside a cage and touching the feathers of a large cockatoo (fig. 92). Caldecott drew this picture knowing that few children would have had an opportunity to see such an exotic bird. This captivating pattern of expectation and surprise continues throughout the rest of the book thanks to Caldecott's suspenseful pictorial narration. As children read the story, they constantly create pictures in their minds to suit certain words, descriptions or actions. Caldecott always had a keen sense of what pictures would mean the most to young people. For example, in the final illustration of John Broom lying down with his dog in front of a roaring fire, Caldecott invoked all of the warm feelings associated with the comfort and security of being at home (fig. 93). After reading about John's arduous journey, children presumably wanted to see their hero satisfied at last. Caldecott's concluding illustration is a fine example of the way he made John's disturbing life appear safe with the iconographic

PRICE ONE SHILLING.

LOB LIE-BY-THE-FIRE
OR THE LUCK OF LINGBOROUGH
BY JULIANA HORATIA EWING

WITH ILLUSTRATIONS
BY
RANDOLPH
CALDECOTT

LONDON
SOCIETY FOR PROMOTING CHRISTIAN KNOWLEDGE,
NORTHUMBERLAND AVENUE, CHARING CROSS, W.C;
43, QUEEN VICTORIA STREET, E.C.;
26, ST. GEORGE'S PLACE, HYDE PARK CORNER, S.W.
BRIGHTON: 135, NORTH STREET.
NEW YORK: E. & J. B. YOUNG & CO.

figure 91

103

moment of John's safe return home to a protective environment. The pictorial happy ending is certainly a mainstay of contemporary children's literature, but effective techniques of illustrating this moment were not fully developed in Caldecott's day. He understood that the serene picture of John and his dog implied more than a rounding off of the plot; instead, it represented a new opening or opportunity for the character. In other words, Caldecott's visual representation of the happy ending signified an opportunity for young readers to contemplate further, and to let the story live on in their minds.

figure 92

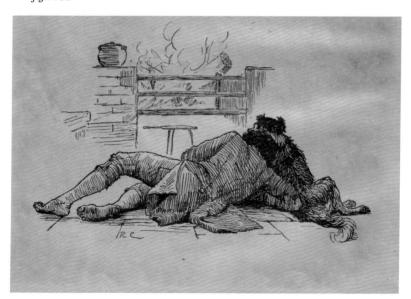

figure 93

THE
OWLS
OF
OLYNN BELFRY

A Tale for Children.

By A. Y. D.

ILLUSTRATED BY

RANDOLPH CALDECOTT

LONDON:

Field & Tuer, The Leadenhall Press, E.C.
Simpkin, Marshall & Co.; Hamilton, Adams & Co.

—

ONE SHILLING.

figure 94

25. The Owls of Olynn Belfry: A Tale for Children
A.Y.D.

London: Field & Tuer, 1886

Featuring twelve full-page and six small illustrations by Caldecott, this book is further testament to his talent for drawing birds. While the author of this story is identified as A.Y.D., we do not know who exactly this person was, but many feel certain that the author was a lady. The illustration of the melancholy governess, Mlle Marie, is particularly touching in the way that readers can easily sympathize with her loneliness and poignant sense of cultural displacement (fig. 95). Caldecott took special care to make her appear quite beautiful with elegant features shared by many French women. The scene with the old owl that guides a miniature fairy queen holds particular charm for children who must have imagined all sorts of magical possibilities after witnessing such an enchanted scene. Another delightful scene for young children is entitled, "Watching for the old owls" (fig. 96). Caldecott drew a father with his two children enjoying a lovely day outside while they await the return of a family of old owls. The expression of anticipation on the young boy's face must have prompted many young lads to ask their own fathers to take them on a similar owl-watching excursion.

MADEMOISELLE MARIE.

figure 95

WATCHING FOR THE OLD OWLS.

figure 96

26. Jack and the Bean-Stalk: English Hexameters
Hallam Tennyson
London: Macmillan & Co., 1886

Caldecott never saw the publication of this title in 1886, the year of his untimely passing. And while many of the pencil drawings are in an unfinished form, they remain excellent examples of Caldecott's exceptional talent. This story was bound with an appropriately earthy green cloth, and the illustration of the giant on the front cover is a remarkable example of Caldecott's ability to convey the same sense of disparity in body size that one would find in representations of "David and Goliath" (fig. 97). The giant's outstretched hand is half the size of sylphlike Jack, and a pins and needles climactic moment results from the way that the giant's hand looms so precariously above Jack's head. In another scene where Caldecott used scale to build suspense, Jack discovers the giant's wife in the kitchen, and we see that her ladle is nearly as large as Jack's body (fig. 98). This classic tale has been popular with children of all ages for centuries, but Caldecott added a special dimension to the story with his humorously oafish depiction of the giant. The giant is fat, stupid, and forever being outwitted by a youthful Jack who is shown with all the grace and elegance of a fine ballet dancer. In the drawing where the giant furiously throws himself from a thick vine to stomp on Jack and prevent his escape from the castle in the clouds, Caldecott provided a unique cathartic moment for his readers by showing the giant lying dead on the ground in the bottom half of the same page (fig. 99). The scene is terrifying and comical at the same time, providing a special opportunity for readers to participate in the emotional ups and downs of a finely illustrated picture book.

figure 97

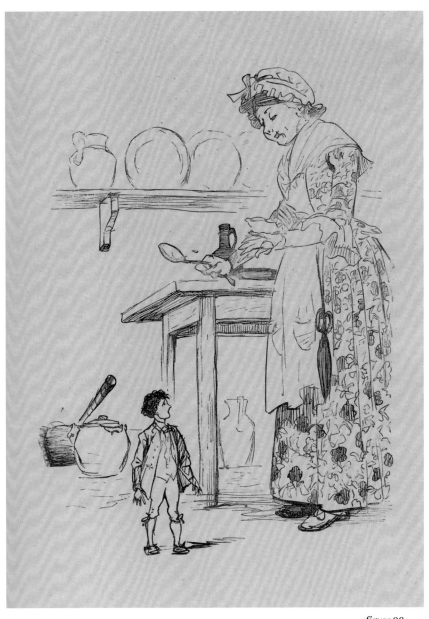

figure 98

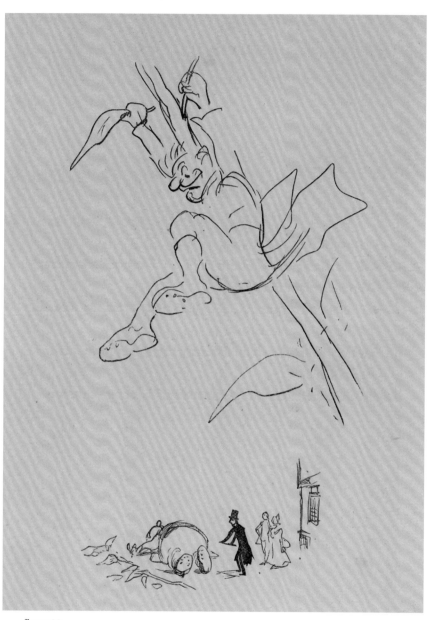

figure 99

Notes

1. Engen, *Randolph Caldecott*, 97–104. Rodney Engen provides an exhaustive list of Caldecott's illustrative work for books and periodicals along with a detailed inventory of his sculptures and paintings in oil. While Engen's listing is considered to be the most authoritative, I found a Caldecott work not listed in Engen's biography: *Eighteenth Century Essays* (1882) selected by Austin Dobson. An illustration of two gentlemen on horseback entitled "The Tory Foxhunter" is used for the frontispiece. One is reminded how much Caldecott loved animals. His many drawings of horses, in particular, were remarkably faithful to their appearance.

2. Billington, *Randolph Caldecott Treasury*, 65. Billington also noted that 30,000 copies of *John Gilpin* and *The House that Jack Built* were delivered for Christmas in 1878 (ibid., 60).

3. Included in Hutchins, ed., *Yours Pictorially,* is a letter from Caldecott to William Clough (dated 8 November 1879) where Caldecott wrote that he was "very stomachily seedy" while creating the designs for *The Babes in the Wood* (38).

4. The microfiche of the archives of George Routledge & Company (1853–1902) indicates that the *Sketch-Book* had a second printing in 1884 (4,000 copies), a third printing in 1886 (4,000 copies), and a fourth printing in 1888 (3,000 copies).

5. Davis, *Randolph Caldecott*, 36. Mrs Gatty (1809–1873), mother to Juliana and Horatia, established *Aunt Judy's Magazine* (1866–1885) as ideal for publishing Juliana's stories. The magazine's name was based on Juliana's nickname.

Works Cited

Billington, Elizabeth T., ed. *The Randolph Caldecott Treasury*. New York: Frederick Warne, 1978.

Blackburn, Henry. *Randolph Caldecott: A Personal Memoir of His Early Art Career*. London: S. Low, Marston, Searle & Rivington, 1886.

Davis, Mary Gould. *Randolph Caldecott: An Appreciation*. New York: J.B. Lippincott, 1946.

Dobson, Austin, ed. *Eighteenth Century Essays*. London: Kegan Paul, Trench & Co., 1882.

Engen, Rodney. *Randolph Caldecott: 'Lord of the Nursery'*. London: Oresko Books Ltd., 1976.

Evans, Edmund. *The Reminiscences of Edmund Evans*. Edited by Ruari McLean. Oxford: Clarendon Press, 1967.

Hartrick, Archibald Standish. *A Painter's Pilgrimage Through Fifty Years*. Cambridge: The University Press, 1939.

Hutchins, Michael, ed. *Yours Pictorially: Illustrated Letters of Randolph Caldecott*. London: Frederick Warne & Co. Ltd., 1976.

Muir, Percy. *Victorian Illustrated Books*. London: Batsford, 1971.

Pennell, Joseph. *Pen Drawing and Pen Draughtsmen*. New York: Macmillan Company, 1920. New York: Da Capo Press, 1977.

Acknowledgements

I would like to thank the staff of the Bruce Peel Special Collections Library for their invaluable assistance. Jeannine Green, in particular, has been a constant source of inspiration for all book-related endeavours. Merrill Distad is also owed a significant debt of gratitude for his strong leadership in our book community, and for sharing his vast knowledge about the extraordinary world of book collecting. His passion is truly infectious. I wish to extend a special note of gratitude to Carl Spadoni for serving as role model in a noble profession. Linda Distad provided expert editorial direction, Carol Irwin imparted her creative skills to the installation of the exhibit, Jeff Papineau provided technical expertise, Cameron Treleaven supplied the Victorian games for the exhibit showcases, and Anne Lambert of the Department of Human Ecology furnished the Victorian children's apparel for the exhibit. Cathy Roy, of the Royal Alberta Museum, was particularly supportive, supplying the exhibit with a charming selection of Victorian toys.

Printed in 9.5 point Arnhem, with the titles in Arnhem Fine, on 100 lb. Luna Matte Text, by McCallum Printing Group Inc., Edmonton, Alberta.

The Arnhem typeface was developed in the late 1990s by Fred Smeijers, a Dutch type designer, when he was asked to create a new type for the Dutch government's daily newspaper, the *Nederlandse Staatscourant*. Smeijers knew that newspaper readers required a highly legible font that could be read easily despite the format challenges, such as tightly packed lines and small font sizes. The result is a wonderfully elegant font where readers benefit from practical design and dark colour, which ensures that the typeface is remarkably legible in smaller font sizes.